# LEARNING FROM THE PROS

## BY THE EDITORS OF AMERICAN ARTIST MAGAZINE
## FOREWORD BY WENDON BLAKE

**WATSON-GUPTILL PUBLICATIONS/NEW YORK**

Copyright © 1984 by Billboard Ltd.

First published 1984 in New York by Watson-Guptill Publications,
a division of Billboard Publications, Inc.,
1515 Broadway, New York, N.Y. 10036

The entire text of this book has been previously published and copyrighted in
the United States by Billboard Publications Inc.
All works of art reproduced in this book have been previously copyrighted by
the individual artists and cannot be copied or reproduced without their
permission.

**Library of Congress Cataloging in Publication Data**
Main entry under title:
Learning from the pros.
    1. Painting—Technique.   I. American artist.
ND1500.L4   1984   751.4   84-3562
ISBN 0-8230-2680-9 (pbk.)

Distributed in the United Kingdom by Phaidon Press, Ltd.,
Littlegate House, St. Ebbe's Street, Oxford.

Manufactured in Hong Kong.

1 2 3 4 5 6 7 8 9/88 87 86 85 84

# CONTENTS

# FOREWORD

**Learning from the Pros.** This stimulating book is the joint effort of seventeen noted contemporary painters. Over the years, *American Artist*—the most widely read art magazine in America—has published an extraordinary variety of technical articles. Each article is a kind of private class that features a distinguished painter who focuses on some specific technique, subject, or problem, and offers the sort of personal guidance that you'd be lucky enough to get if you met the artist face-to-face. *Learning from the Pros* brings together seventeen of the most popular and practical of these articles from the pages of *American Artist*. Each artist teaches a unique and personal lesson.

**Oil Painting Methods.** Oil is the most popular painting medium, and seven different painters offer problem-solving ideas. Joseph Dawley shows how to paint still life objects in a way that really captures their three-dimensional quality and their surface texture. Lee Seebach focuses on an approach to landscape painting that emphasizes the observation and accurate recording of color. Phil Koch takes you outdoors and demonstrates a fresh, spontaneous approach to landscape painting on-the-spot—working with the unfamiliar combination of oil on paper. Sybil D'Orsi is particularly fascinated by the effect of sunlight, and shows how she captures the drama of natural light on flowers and other still life objects. E. John Robinson prefers to paint his large and complex seascapes indoors, and shows you how he works from sketches and notes. Portraits are normally painted under pressure, and demand an efficient, organized approach: Jan Herring demonstrates the logic of the direct or *alla prima* method. Gary Michael explains how he paints realistic landscapes based upon imagination, memory, and the creative reconstruction of nature.

**Watercolor Techniques.** Emphasizing the importance of *planning* to achieve a feeling of freshness and spontaneity, Irving Shapiro shows the importance of drawing as the foundation for a successful watercolor. Jeanne Dobie stresses the importance of a planned design in a watercolor, paying particular attention to the shapes of the white paper. Carlton Plummer also feels that a successful watercolor depends upon design, and talks specifically about how diagonal compositions enhance his landscapes and seascapes. Many watercolorists would like to try portraits, but they're put off by the apparent technical difficulties; Gordon Wetmore demonstrates a simple, logical, direct approach that will encourage *you* to try watercolor portraits for yourself. Alan Singer tells us how he tries to capture the poetry in nature by planning his paintings and then working quickly and spontaneously. Watercolor is a particularly satisfying medium for working on location, and Timothy Clark takes you with him on a painting expedition to Venice, where he shows you how to deal with the special problems of painting outdoors. And Stephen Quiller paints a landscape that combines acrylic, gouache, transparent watercolor, and collage, spotlighting the growing interest in combining the various watermedia in a single painting that exploits the unique advantages of each medium.

**Other Media.** Three artists bring fresh viewpoints to other media. Douglas Atwill paints landscapes in acrylic, adapting them freely from photographs. "Pastel painting is enjoying a rebirth," says Daniel E. Greene, who explains the fundamentals of this "purist form of painting," which is a medium he uses primarily for portraits and figures. More and more artists are discovering oil pastels, and John T. Elliott explains how he uses them for portraits, landscapes, and still lifes.

**Ideas for Experimentation.** As you can see, *Learning from the Pros* is essentially an "idea book." The purpose of the book is to surprise and energize you by introducing fresh approaches to familiar problems. As you turn these pages, I think you'll find yourself saying, "Ah, I never thought of trying it that way!" or "That's the solution I've been looking for!" The fascination of this book is the unexpected. Every one of the seventeen contributors to *Learning from the Pros* suggests one or more experiments that could bring new vitality to your painting. And just one of these experiments might turn out to be worth "the price of the admission" because it leads your art in an important new direction!

WENDON BLAKE

# PAINTING WITH OILS

### BY JOSEPH DAWLEY

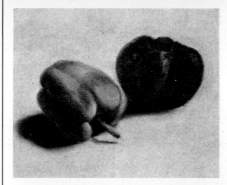

2

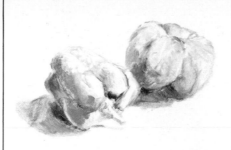

1

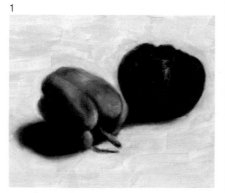

3

4

**Joseph Dawley** *received his B.A. from Southern Methodist University where he was honored with their highest art award. His work has been included in collections throughout the U.S., in the Collector's Covey (Dallas), and in Calvert Gallery (Washington, D.C.). His many awards include the Salmagundi Award and Allied Artists of America, Inc., Show (1969). He lives in Cranford, New Jersey, where he owns the Joseph Dawley Gallery. With the help of his wife, Dawley is the author of four books, published by Watson-Guptill: Character Studies in Oil (1972), The Painter's Problem Book (1973), Painting Western Character Studies (1975), and The Second Painter's Problem Book (1978).*

THE OIL painter often encounters objects that are technically difficult to paint because of some unique property they possess—the texture of a fabric, like velvet, for example, or the transparent quality of glass. Natural objects, such as vegetables, present their own set of problems. How can you paint them so that they'll look real instead of plastic? This demonstration focuses on capturing the special quality of smooth, shiny vegetables—namely, peppers. The techniques demonstrated here should help you paint other vegetables and fruits, as well.

### COLORS AND MIXTURES

For the initial drawing, I'll be using a mixture of ultramarine blue and flake white. You'll notice that I keep the painting in a low key, until the final stages, by limiting my palette and dulling my colors. The primary background will be a mixture of ultramarine blue, yellow ochre, and titanium white. Ultramarine blue and raw umber will provide the dark tones. In the final steps, I'll introduce the bright colors with a mixture of yellow ochre, earth green, and chromium oxide to create the peppers' green shades and a mixture of cadmium red light and yellow ochre for the warm reds.

### BRUSHES, PAINTING SURFACE

Since peppers are smooth, shiny vegetables, I've chosen a smooth painting surface—Masonite® prepared with white gesso. It's a special board I manufacture under the tradename "Dawley Board." The smooth surface of the subject matter also influences my choice of brushes. I'll be working exclusively with sable brushes in a variety of sizes, from a small No. 2 Kolinsky red sable watercolor brush to a large ⅝" flat sable and several sizes of flat sables in between. By using sable brushes, I can prevent brushstrokes from becoming too prominent and thereby destroying the illusion of smoothness that I want to create.

Now, let's begin our painting. And remember to keep your peppers in the refrigerator when you're not referring to them, as they deteriorate quickly.

### THE DEMONSTRATION

**1.** The shapes of peppers are easily rendered and present very few drafting problems. In this preliminary step, I try to capture the shapes of the peppers and their relationship to each other. I've purposely chosen a color mixture—ultramarine blue and white—for this step, which is vastly different from the finished hues, so that I won't be tempted to pass over this important drawing stage too quickly. I'm working here with a ¼" sable and a ⅜" sable. In areas that require darker tones, I add more blue to my mixture; when I need a lighter tone, I add more white.

2. Before I begin this step, I check for any buildup of paint that may have occurred and carefully smooth it out with a palette knife. Using a large ⅝″ sable, I mix a background color of ultramarine blue, yellow ochre, and titanium white and paint around the peppers and their cast shadows. Then I fill in the entire background. With ultramarine blue and raw umber, I paint the cast shadows, blending the edges into the background color to maintain softness. Next, I model the peppers with my green mixture (yellow ochre, earth green, and chromium oxide) and the red mixture (cadmium red light and yellow ochre), also working some dark tones of ultramarine and raw umber into the shadow areas where needed. I do not let this stage dry, but proceed directly to the next step.

3. Now I begin to paint the peppers and the background with more detail. I intensify the background by brushing in more of the background color mixture (ultramarine blue, yellow ochre, and titanium white). I rework the shape of the reddish pepper with the red mixture (cadmium red light and yellow ochre) and more firmly define the shadows on the peppers to enhance their curved proportions. Using less of the dark shadow tone (ultramarine blue and raw umber), I blend the existing shadow color into the pepper color. Then I soften the shadow underneath the peppers by brushing in some background tone. Finally, I add white highlights with a ⅛″ sable and allow this stage to dry completely before continuing with the painting.

4. In this final step, I strengthen and brighten all the colors. I repaint the entire background with a mixture of yellow ochre and ultramarine blue with just a touch of white. Into the green of the pepper, I work cadmium green (toned down with chromium oxide). Chromium oxide is painted over the dark shadow areas within the pepper, as well as in the cast shadows, in order to subdue those very dark tones. To prevent harsh edges and preserve the curvature of the peppers, I blend the edges by brushing all colors back and forth, and I brush the outer edges of the peppers and their cast shadows into the background color to maintain their softness. The red areas are made more intense by "over-painting" with a mixture of cadmium yellow and cadmium red light. I also add small amounts of cadmium yellow to the green areas of this reddish pepper where a yellowish hue is required. To complete the painting, I flick in some white for highlights with the small ⅛″ brush or with the Kolinsky sable. And now the peppers look smooth, cool, and fresh enough for tonight's salad! ●

# DIRECT PAINTING OUTDOORS

BY PHIL KOCH

Photos of works in this article by Richard Shannon.

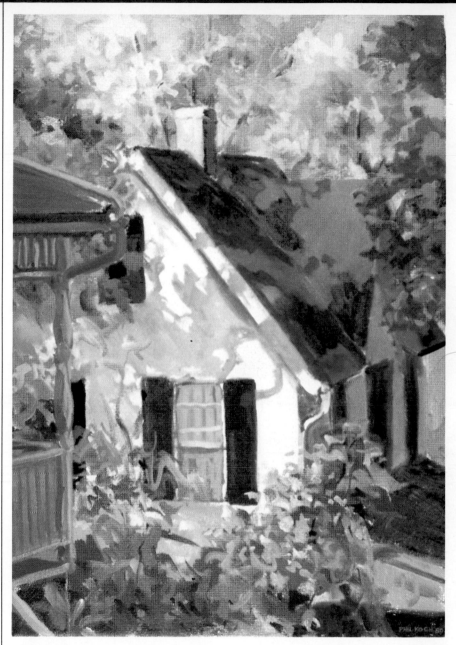

Photo: Alice Jonas

Right: *The Roof*, 1980, oil, 20 x 14. Works this spread courtesy Gross McCleaf Gallery, Philadelphia. This picture began as a horizontal view that included a large porch at the left. Realizing, however, that the house on the right held the most interest, Koch cut off the left half. "My aim was to integrate the house with the foliage by focusing on the shadow on the walls and roof," he says.

Opposite page: *Railroad Crossing*, 1981, oil on paper, 17⅞ x 24⅝. These old railroad signals reminded Koch of David Smith sculptures: "I liked the way the morning sun lit them and the way the shadows snaked across the tracks. Although it was a summer painting, I altered the colors of the trees—they are considerably different than the predictable greens."

P AINTING outdoors gives an unmistakable feeling to the work produced. Its challenge has brought the best out of painters, from Corot to Edward Hopper. While it has confused and demoralized too many others, its special problems continue to excite some of our best contemporary artists. It provides a unique and changing source. It is, literally, a living source. As the landscape painter Wolf Kahn told me, "Especially when you work from nature, you don't have to worry about being a stick-in-the-mud. Nature forces you to change; you see too many new things all the time."

What interests me is not so much what I paint as how I handle it. Everything I do when I paint is aimed at deepening my personal response to the subject. Painters who choose to work from direct observation usually feel that photographic sources don't provide enough information. It might be more accurate to say that direct observation gives too much information, but that this forces the artist to see in a more personal and selective way. An outdoor painting source compounds the situation because, in its scale, it offers far more planes and colors than any indoor or imaginary source can. It deluges the painter with too many possibilities for any one painting. What's more, it moves before you in the wind, the shadows endlessly shift around, and the weather never stays precisely the same two days running.

I enjoy the slowness of struggling

7

with drawing my observations directly on the canvas. Staring at the source for hours gives me the necessary time to notice the ways separate forms connect with each other and to ponder which relationships to stress in the finished painting. It takes me several days, painting layer over layer, to arrive at a clear idea of what I want. The purposely vague initial stage is painted over several times as I correct earlier mistakes in interpretation. I am reminded of Charles Burchfield's observation that you can develop a picture only along an indirect path like that which a sailboat must take tacking into the wind.

To save all my energy for this mental wrestling match, I try to keep my methods and equipment as simple as possible. I store everything I use in a highly portable French easel—a combination paint box and folding easel imported by Grumbacher. It has a big advantage in that it holds the picture tight with adjustable clamps against the inevitable gusts of wind. With it I can paint standing up, keeping me more alert and allowing me to step back continually from the easel to view the picture as a whole. Also, since I usually find what I want to

work from while walking, I want to be able to paint it from exactly the same point of view. It never looks as good once you are sitting down on the ground.

The size I work at determines roughly how long a picture will take to paint. In my experience, working on a painting with sides over three feet long gets unmanageable. I think most artists today feel pressured to paint larger than they really should. I recommend modest sizes (12″-24″) to begin with.

For small paintings I use an oil-on-stretched-paper technique: take smooth etching or watercolor paper, soak it in the bathtub for five minutes, and then staple it all around the edges to a plywood board. After it has dried, it is stretched tight. It will take a coat of acrylic gesso without any wrinkling. For larger pictures, I use Masonite board with several coats of gesso, sanded between coats.

Slow-drying oil paint is best suited for the frequent readjustments I make while interpreting a scene. I carry a minimum number of pigments: titanium white, raw umber, burnt sienna, cadmium yellow, cadmium red, alizarin crimson, viridian, and ultramarine

blue. The inexpensive brands give excellent results, so I usually use them. I confess having a long-term love affair, however, with Winsor & Newton's Ultramarine Blue Deep. A clip-on double palette cup holds turpentine and a glazing medium of stand oil, damar varnish, and turpentine.

An important help is to have as many brushes as you can—one for each color you'll be using so you won't have to stop and clean brushes during painting time outside. I use white bristle brushes because I like the way they state the brushstroke clearly. Using flat instead of round brushes reinforces the habit of thinking of the landscape in terms of planes of color instead of in a linear fashion. Also, they simply put down the paint faster.

One last piece of equipment I think is essential is an adjustable rectangular viewfinder. We painters enjoy the subject matter in the landscape as much as the next person. But we have the added responsibility to look beyond the subject and see it in a purely visual way. Try to forget momentarily what it is before you and instead become immersed in the color and movement alone. More than any other tool, a viewfinder helps me to reduce

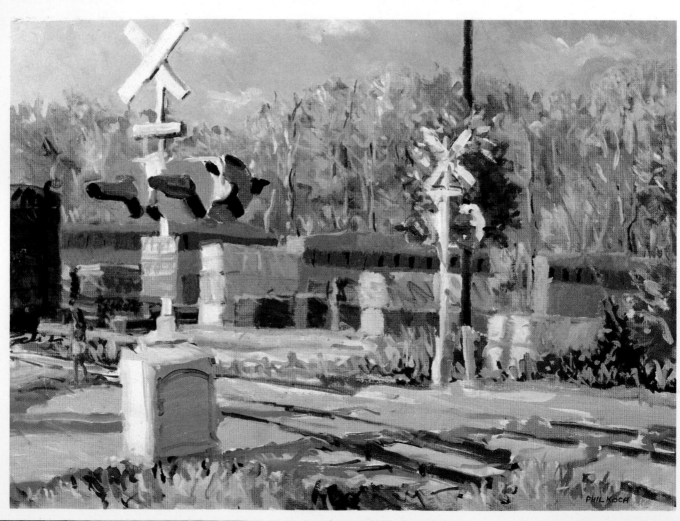

the subject to these abstract terms. I previously used two "L"-shaped pieces of mat board, held together with paper clips, to form a window of the same proportions as my painting surface. I've since discovered I can more easily make a good rectangular window with the first and second fingers of each hand, held at right angles to each other.

Additionally, you have to take steps so you will be comfortable working outside. On a hot day, I'd rather pass up a perfect point of view if it means broiling under the direct sun. Painting behind a windbreak or down in a valley will allow you to work even in gusty winds. The beautiful colors of the winter landscape are within reach if you will dress warmly and wear thin gardening gloves.

I have always been most excited by sunny days and long shadows. This always leads me to paint early in the morning and again later in the afternoon. The 11 a.m.-1 p.m. slot is best for lunch and a nap. I think most painters who are seriously involved with outdoor sunlight don't work longer than two hours at a stretch on the same painting. The shadows change too much after that.

I return again and again to the same spot at the same time of day for as many days as it takes to complete a picture. Obviously, I have several unfinished paintings going at the same time. I can look at a work in progress in the evening and decide where it needs to be worked up the most the next day.

Fine. So what do you paint? My best sources come to me when I least expect to find them. While out jogging or working on another painting, a small section of the landscape will just strike me with its promise. I will become intrigued by how the shapes or colors in a certain area seem absolutely right together. They will seem to interlock like the pieces of a picture puzzle. To check it out, I try hard to visualize it as if it already were a painting, looking through the viewfinder for areas that could give me trouble. Does each area suggest a way for itself to be handled? If the answer is "yes," I take a deep breath and jump in.

The first four to five shapes I put down are the skeleton that supports the rest of the picture. These first few shapes should be large enough so that they connect opposite or adjacent

sides of the rectangle. They have to contain the picture's main feeling of movement. I describe them with a thin turpentine wash of ultramarine blue. In the painting *Fisherman*, my first decision was that the surface of the water was what held real interest and that I wanted to avoid involvement with the shore. The first few lines described the way the water's surface moves back into space in alternating smooth and rippled bands. The horizontal sweep of these lines was to dominate the rectangle. Second, I drew in some of the vertical reflections of tree trunks. This kind of tension between the two opposing forces drives the picture forward.

Moving on as quickly as I can, with as large a flat brush as I can make fit the size of the biggest areas, I begin to fill in areas of color where there will be middle or dark tones. It's good to try these initial colors as transparent washes. I like to add just a touch of the glazing medium in these washes. The corrections I do over them are painted progressively thicker, with white pigment added as needed.

In this first session on the painting, I simply try to get an allover feeling for the color and movement. It would be

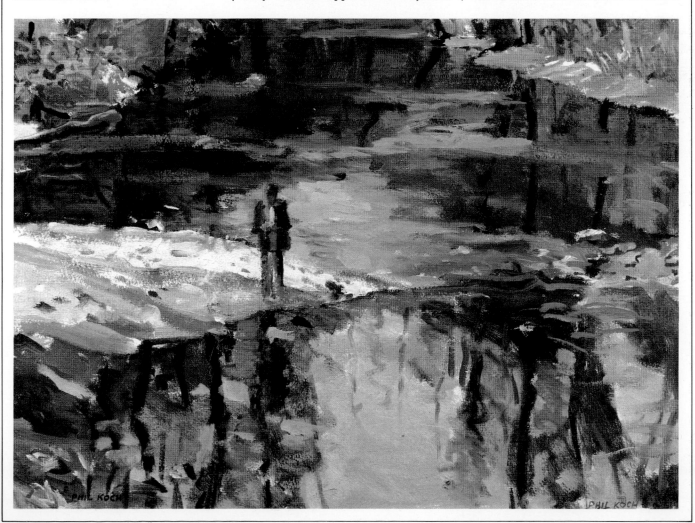

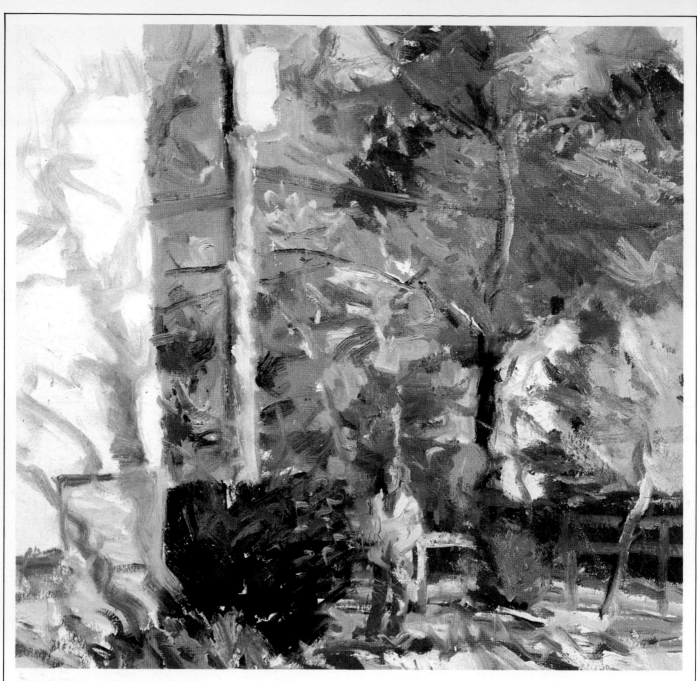

Above: *October*, 1981, oil on paper, 13¼ x 13½. Courtesy Gross McCleaf Gallery, Philadelphia. "I painted this on one of those outrageous October mornings," says the artist. "I included the corner of the white house as a restful area to contrast with the activity in the trees."

Left: *Fisherman*, 1981, oil on paper, 13 x 18. Courtesy C. Grimaldis Gallery, Baltimore. "This figure stepped into the painting on the second day. He seemed at home, so I included him," notes Koch. "I left out a great deal of information about the rocks, as the painting seemed to be full enough, with the interest on the water."

fatal to become involved with any details whatsoever at this point. It's job enough to cover up all the white gesso areas the first day. The smearing and blending that occur naturally from working wet-into-wet are appropriate because you are just getting acquainted with the new picture. Be vague until you figure out what you want to say.

Many painters do too much with color in the initial stages. I simply try to play off a bright area of color against any one of a number of grays mixed from ultramarine blue, burnt sienna, and white. The big color chord in *Fisherman* is the warm sienna in the water juxtaposed to the cool gray reflections of the sky.

For such a small painting, I returned two more times to the location to

paint over the first stage. These sessions are more demanding because you are adding elaborate new information but hoping not to subvert your initial main sensations. In good, sensitive painting, certain forms seem to float toward you and demand to be noticed first. This is how an artist speaks to the viewer about what he or she has found most exciting.

By the second or third morning, I will have put down many more perceptions about the source. Some of them will be at odds with the first day's painting. These discrepancies are resolved by bringing the moves that really please me into sharper focus to demand attention for themselves. Ideas that don't fit the developing scheme must be softened. You have to be willing to repaint vir-

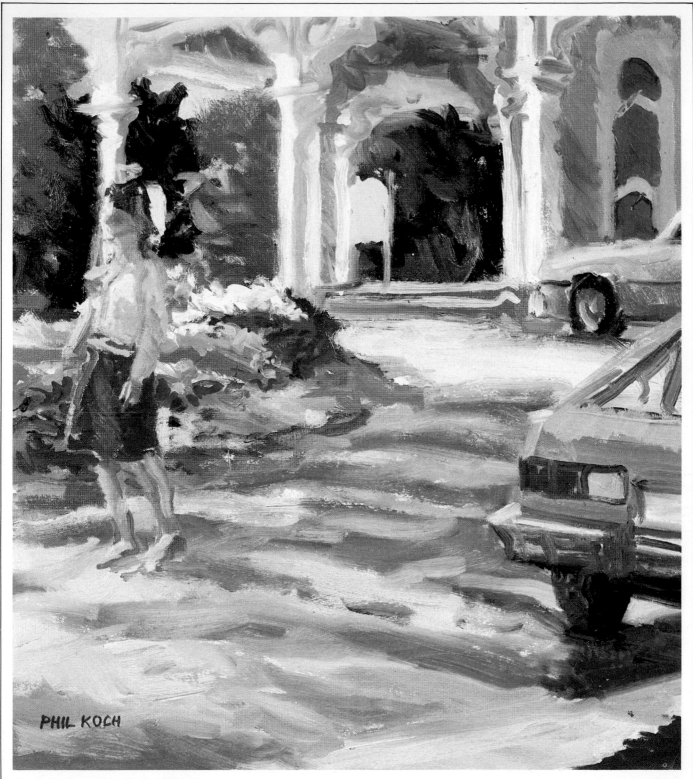

PHIL KOCH

Above: *Porch and Flowerbeds*, 1981, oil on
paper, 12⅞ x 11½. Courtesy Gross McCleaf
Gallery, Philadelphia. This painting began as
a horizontal painting, but as the artist became
more interested in the shadows on the pave-
ment, he added a section at the bottom.

Right: *Boatyard*, 1981, oil, 8½ x 15¾. Cour-
tesy C. Grimaldis Gallery, Baltimore. Koch
chose this subject of a boatyard in Wellfleet,
Massachusetts, for the repeated blues and
similar curves in the boats. This was as quick
a painting as he could do, he says. It took him
two long morning sessions and ''a little studio
fine tuning.''

tually the entire painting to get this kind of control. In painting over the dry colors of previous sessions, there is the danger that the new paint won't really "connect" with what's below. I'm dependent on the slow drying time of oils to give me maximum say about which edges will be sharp or soft. To finish off an area that has been previously sketched in, I will often paint the entire area over again so it can be worked wet-into-wet.

In looking at the source for *Twin Bridges*, I was fascinated by the way the straight metal girders gradually emerged from the soft foliage. I added a new layer of the yellow foliage in back of the bridge over the original sketching. Then I worked up the crisscrossing beams, letting some of the edges get lost in the puddle of wet paint. When it is done right, the result is a very subtle and flickering beauty. This range of feeling for edges is almost impossible to achieve with acrylics.

Just as I try to begin each painting with a concern for the big gesture, I start the succeeding days' sessions with a focus on the gesture of the smaller parts. Gesture is most obvious in painters such as Franz Kline or the Italian Futurists, but it must ultimately be seen as a refined and subtle quality that flows through every part of a painting. I rely on the gesture of the smaller brushstrokes to modulate the first large planes as I work back into them. In *Fisherman*, I became aware that the vertical reflections

were too numerous. So some areas of the water were smoothed out to play off against the places where these reflections remained sharp.

This calligraphy of the strokes provides a fascinating continuity between the Old Masters and many contemporary painters. I think I learned the most about it from standing very close to Rembrandt and Monet and tracing the trajectories of their brushwork. Brushstrokes must fit the form they describe but surprise you at the same time. In filling the color into a plane, I try to move my brush in an unexpected way, often against the axis of a form. For example, in the right-hand bridge in *Twin Bridges*, I formed the large, nearly vertical girders out of a row of short, staccato, diagonal strokes. It was more difficult to do, but it suggested an additional way to read the form.

When I feel I'm about three-quarters finished with a painting, I begin to sense I've taken about all I can from the source. The actual appearance of the landscape can tyrannize your thinking. Back in the studio, the painting seems to take on its own identity more easily than when outside. It's here that I make my final decisions on how to conclude the picture. I'm always willing to make big changes, working just from my imagination. For example, in *Railroad Crossing*, there was originally a larger expanse of forest and only one small warehouse at the left. I found I had nothing to say about so many trees and, in-

stead, invented two additional warehouses to block them out. In other cases, this reflection in the studio may send me back outside with a model to populate a too empty space. This happened with *Porch and Flowerbeds*.

Sometimes I find myself so intrigued with the problems of an on-the-spot painting that I want to use it as a study for a large studio painting. The picture *Marshes* was developed from a small oil done on Cape Cod, with a great deal of invented information added to keep each square inch of the painting as visually rich as the study. The thousands of hours I've spent painting outdoors have allowed me to do this. ●

**Phil Koch** *was born in Rochester, New York. He first became interested in painting when, as a student at Oberlin College in Ohio, he took an introductory art history class that met next door to the painting studio. ("It smelled more interesting," he explains.) He received an MFA in painting from Indiana University where he began doing landscape work. Since 1973, he has taught drawing and painting at the Maryland Institute, College of Art in Baltimore. His work is represented by the Swansborough Gallery in Wellfleet, Massachusetts.*

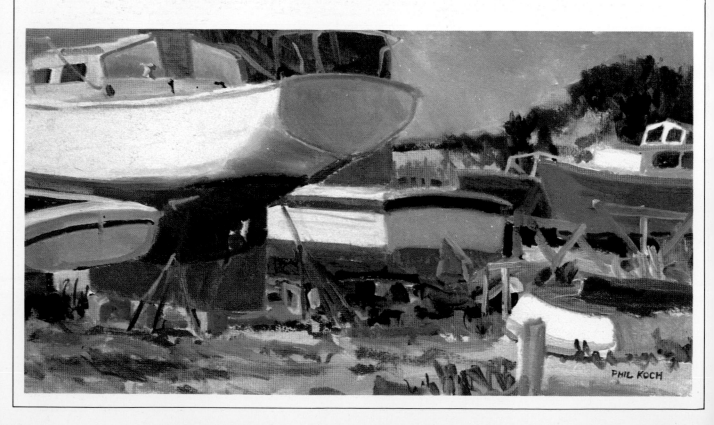

PHIL KOCH

# PORTRAIT PAINTING ALLA PRIMA

BY JAN HERRING

1

2

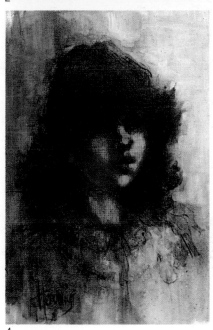

3

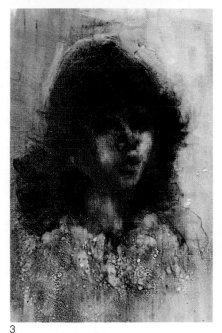

4

1. Sketching with Conté crayon.

2. Laying on thin oil glazes.

3. Lifting glazes from areas to show light patterns and to define contours.

4. Applying opaque paint over the glazes. The finished portrait: *Nicole*, 1981, Conté and oil, 16 x 12. Collection the artist.

**M**ASTERING THE ART of portrait painting is for me the ultimate challenge. There is nothing quite as fascinating as the form of the human head. Of course, there are times when a restless child makes me wish my model was, instead, a simple bouquet of flowers. Despite those frustrating moments, I must admit that the portrait has remained my favorite subject.

There are various methods of approaching the portrait, but the simplest and most direct is alla prima. Alla prima implies an immediate statement that does not require laborious underpainting. My temperament is such that when painting becomes work, I would rather be playing golf (which I hate). Consequently, the rapid-fire alla prima technique sustains my enthusiasm and is compatible with my lazy and impatient nature.

There are other advantages to alla prima painting, the most important being the marvelous, spontaneous quality that can result from this quick approach. Oil paint has the unusual characteristic of remaining wet for a good length of time. When you paint

wet paint into wet paint, you achieve remarkably luminous paint quality. Because alla prima painting is such a fast technique, the inspiration and excitement of the moment are maintained throughout the painting process. It is actually possible to paint a portrait from start to finish in less than an hour.

The secret to the technique is the use of an imprimatura, which is simply a tinted or glazed priming. This priming serves as the middle values for the entire painting. Because all the middle values are established before the actual painting begins, only the dark transparent glazes and the light opaque colors remain to be painted. The ground color also tends to unify the whole, because it is left partially exposed.

The imprimatura, whether opaque or transparent, should always be painted over an initial white priming. The white paint creates an inner light that increases the luminous effect of the glazes. I use acrylic gesso to prime canvas or hardboard supports. Either surface should be painted with several coats of gesso so that the surface will be smooth: the thin oil glazes will literally float on the top.

The final effect of an alla prima painting relies heavily on the color and type of imprimatura. You can have a one-color opaque priming, such as gray, blue, burnt umber, pink, green, or ochre, by mixing acrylic gesso with a small amount of acrylic color. A transparent imprimatura can be created with a thin coat of transparent acrylic paint thinned with water. These primings can be one color or multicolored. Another useful imprimatura is made with damar varnish thinned with turp mixed with transparent oil paint. The resulting glaze should dry several days before you paint over it. The varnish imprimatura is especially suitable for hardboard surfaces. My favorite imprimatura on hardboard is pastel chalk. The chalk must be applied to a white gesso priming so that it will appear luminous. It is quick and easy and can be fixed to the surface with spray fixative. An underpainting effect can be achieved by using several colors in specific areas, as in the portrait *Amanda*, or one color, as was used in *Young Man with a Beard*. The one-color procedure is the ultimate in simplicity.

The 16″ x 12″ canvas I chose for the demonstration of *Nicole* was primed with two coats of white acrylic gesso, followed by a very thin opaque imprimatura of pale blue acrylic. When it was dry, I lightly sanded the imprimatura.

The model was posed in a three-quarter position turned towards the

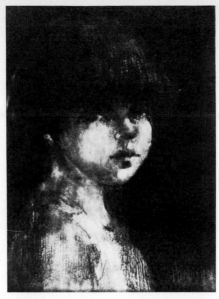

5. *Amanda*, 1980, oil, 14 x 11. Collection the artist. For this portrait, Herring created the imprimatura with pastel chalk over a smooth acrylic gessoed panel, which she fixed with spray fixative. "I used bright red in the background, pink for the flesh, and orange under the dark hair," she says. "The shirt was left white. The oil glazes were burnt sienna and ultramarine blue for the flesh and ultramarine and burnt umber for the hair and shirt. All of the lights were achieved from lifting some of the glaze from the chalk imprimatura. The background was painted with ivory black. The red color underneath enriches and enlivens an otherwise uninteresting color."

light. She was seated slightly above my eye-level to ensure an uninterrupted smooth design from the oval head to the curve of the shoulder. The compositional plan was to create a simple light and dark division of space.

*Step 1.* I made a sketch of the model directly onto the blue-gray imprimatura, using a piece of sharpened sanguine Conté crayon. The red color of the chalk resembles the burnt sienna oil color that I intended to use in the flesh tones. This tool allows for a sensitive, accurate drawing that can be incorporated into the oil paint layers. It also can be easily removed with a little water and a tissue. However, for someone not confident in his or her ability to draw the head accurately, it is best to work on paper and transfer the finished sketch to the canvas. When the sketch was completed to my satisfaction, I washed the sketch with water and a wide watercolor wash brush. The water caused the Conté to loosen a bit and run, thus creating a lovely fluid look. When it was dry, I fixed the sketch with spray fixative.

*Step 2.* I chose a conservative group of oil colors. The transparent colors were ultramarine blue, burnt umber, burnt sienna, Shiva Permasol orange, and transparent ochre (all glazing col-

ors) for the flesh and hair, plus an addition of alizarin crimson for the background and costume. The opaque colors were white, ochre, and cadmium orange.

Before I began the painting session, I conditioned all of my paint with a mixture of one part damar varnish and one part stand oil, which had been thickened to the consistency of honey by allowing it to stand in a shallow pan for a few days. Each mound of paint received a small addition of this mixture, which not only improved the brilliance, but also increased the viscosity of the paint. The resulting mixture allowed me to push about the colors vigorously without losing their identifying characteristics. Preconditioning of tube paint is essential if the wet-in-wet method is to succeed. Without it, the colors would mix into a gooey gray mess.

One of the best painting mediums presently on the market for alla prima painting is Grumbacher III. One can, however, mix a good medium with one part damar varnish, one part turpentine, and one part sun-thickened linseed oil. Five or ten drops (optional) of cobalt drier can be added to speed the drying time. A generous amount of medium is necessary to thin the transparent paints for the best glazing effects.

Soft, wide sabeline watercolor brushes are excellent for the laying on of the thin glazes. I use an inch-wide (Delta 160 Series) one-stroke sabeline. It has extra-long fibers and is soft, yet tough enough to paint vigorous passages. The brush also is available in ½″ and ¼″ sizes that are perfect for painting details of facial features.

I brushed a mixture of burnt sienna, orange, and ochre quickly over the entire flesh area; a mixture of ultramarine and burnt umber over the hair; and ultramarine and alizarin into the background and costume areas. I followed this glaze immediately with a mixture of ultramarine and burnt umber across the eyeline, down through the shadow side of the model, and onto the side planes of the head and neck. This was all painted rapidly with the inch-wide brush. The entire surface was covered with dark transparent glazes. Simplicity of brushstroke is important in order to increase the spontaneous quality. All the dark values should go on quickly so that the glazes will mix and dry at the same rate.

*Step 3.* At this point, the surface was a single "juicy" layer of thin, wet transparent paint. The paint was thin enough so that the drawing and imprimatura were still visible. Using a tissue wrapped about my index finger, I began to lift the glazes gently from all the spaces that fell into the

light pattern. The structural planes must be well understood in order for the three-dimensional quality of the head to emerge from the wet, dark glazed mass.

If one can visualize the head as a six-sided box, the planes can be readily understood. The head divides into top, bottom, front, back, and two side planes. The front planes (forehead, top of nose, and both cheeks) terminate at the base of the nose and cheeks. The bottom planes are the recesses of the eyes, the undercut at the base of the nose, the upper lip, the shadow under the lower lip, and the base of the chin. The nose is a separate form with four visible planes.

The front and side planes of the head are the ones that dramatically change in value with the light source. The top of the head tends to remain in middle values; the bottom is usually indicated by deep shadow. If the head is turned in a direct frontal position, the front planes will fall into a middle value, with one side plane in light and the opposite side plane in dark. When the model is posed in a three-quarter position facing the light source, the front planes will be in light and the close side plane in shadow, as seen in *Amanda*. If the model is turned away from the light source, the front planes fall into shadow with the close side plane in light, as in *Young Man with a Beard*. This last one is the easiest lighting pattern, because the complicated features are in shadow. This position allows for some flexibility when there is indecision on the painter's part.

*Nicole*, however, is the artist's perfect model, so she was posed with all her lovely facial features exposed to the light. The light areas were actually developed by subtracting paint from the surface, exposing the imprimatura. The still lighter opaques were then added in the center of the lifted-off area to create a gradual transition from dark to light. Glaze was left at the contour lines of the features, hair, and outer edge of the head.

Once the light planes of the head were developed in this manner, I lifted the glaze from the nostril, earlobe, and contour line of the inner cheek. All of these lights are reflected lights and can best be expressed when they are drawn from the imprimatura rather than by direct opaque painting. The glaze was also lifted from the light front planes of the neck and shoulder. The background was then relieved of a portion of glaze, allowing the dark pattern to "settle" at the back of the head. The contour of the skull was identified by lifting the glaze about the crown, exposing the soft color of the imprimatura.

By this time, the paint was becoming "tacky." A glaze must reach a stage of stickiness before the next layer of paint can be introduced. I reestablished the drawing with burnt sienna, a color that matched the line drawing of the Conté chalk. I selected a ¼" sableline watercolor brush and developed the details of the eyes with ultramarine blue and burnt umber. The bottom planes of the nose, mouth, and chin were painted with the same color, as was the dark wedge shape on the broad plane of the cranial oval. The actual painting time up to now could not have exceeded 45 minutes.

*Step 4.* Superior color effects result when the glazes are still wet enough to introduce the light opaques, but are sticky enough so that the opaques will stay put. If the glazes are too wet, the opaques will drown in the soupy paint. If they are too dry, they will sit on the top of the glaze.

I like to mix the opaque paint on my palette until I have a color that matches the area color; then I slightly lighten it. Because the burnt sienna and orange glaze warmed the cool imprimatura, I mixed the lights with orange, ochre, white, and a touch of ultramarine blue. This mixture was then applied to the light front planes with a No. 6 bristle brush. A light gray-blue opaque was mixed for the background and a pinkish hue was mixed for the costume. A few touches were added to increase the linear quality, and the painting was finished. The final effect was one of splendid spontaneity. ●

*Jan Herring resides in Clint, Texas, where she is surrounded by her husband, children, grandchildren, and 2,000 dairy cows. This is where the majority of her painting is done and where she maintains her winter studio. In the summer, she moves to Cloudcroft, New Mexico, where she has a studio and a classroom that accommodates 20 students. She conducts classes from June to August.*

*She has authored and published two books: The Painter's Composition Handbook and The Painter's Complete Portrait and Figure Handbook (Poor-Henry Publishing Company, Clint, Texas).*

*Herring's paintings can be seen by appointment at both her studios. She is represented in Texas by The Galleries of San Angelo, L & L of Longview, Dos Pajaro, El Paso; McCloud Gallery, Eastland; Hurt Galleries, Odessa; and Tom McAllister, Fort Worth. Other galleries that exhibit her work are Spellman Gallery, Fort Walton, Florida; Art Factory, Portland, Oregon; and Wadel Gallery, Santa Fe, New Mexico.*

*She has had more than 300 solo shows and has won many awards.*

# PAINTING THE SEA FROM SKETCHES AND NOTES

BY E. JOHN ROBINSON

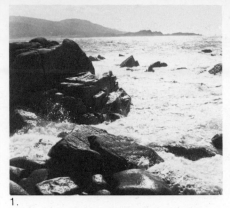

1.

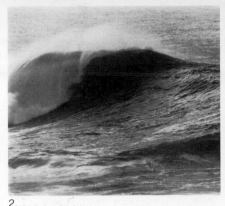

2.

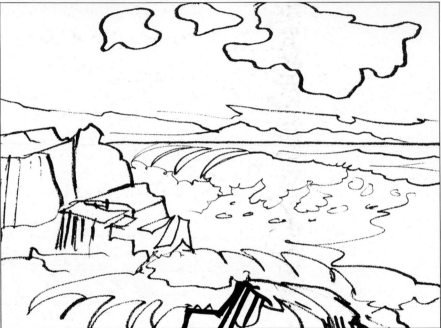

3.

*E. John Robinson is the author of* Marine Painting in Oil, The Seascape Painter's Problem Book, *and most recently,* Master Class in Seascape Painting, *all published by Watson-Guptill. He has painted three covers for* Reader's Digest *in addition to other illustrations for the magazine. His work has also appeared in other magazines both in the United States and England. He no longer gives private lessons but encourages his students through his books and especially through study of the sea itself. Robinson's work can be found in The Ruth Carlson Gallery, Mendocino, California; The Zantman Art Galleries, Carmel and Palm Desert, California; The Lincoln Art Galleries, Lincoln City, Oregon; and The Canyon Art Gallery, Canyon, Texas.*

IT IS NOT ALWAYS convenient to paint right on the scene. The weather may be poor, there may be crowds of people, you may not have the time, or there simply may not be a comfortable spot to set up an easel.

When this happens, I brave the weather, the people, and my comfort to make a quick sketch and take a few photographs. I carry a drawing tablet, a felt tip pen, and two cameras—one for black-and-white and the other for 35mm color photographs. The color may not be accurate, but it will jog my memory later. The black and whites are most helpful in seeing the values that may otherwise be covered by the color.

### SKETCHING

There is a trick to watching waves. They seem to move too quickly to capture but that is because you see every movement. To help fix their action, try looking through the viewfinder of your camera until you have framed the area you like. Now open and close your viewing eye slowly so that you catch only specific moments. When you have just taken an imaginary picture of a good wave with your eye, turn away, close your eyes, and examine your memory of that moment. With practice you will be able to study your memory pictures as if they were photographs held before you.

Be patient while watching the waves. The big ones come in groups every few minutes and the lighting may change. Also, stand back from the action or you may become a tragic statistic—I use a telephoto lens, which forces me back from the water's edge.

When you have found the combination of elements that impresses you, make a quick sketch or two. I sometimes make just an outline if there is a particular arrangement I like. Other times, when only one element is outstanding, I may make a more detailed drawing of it along with notes about

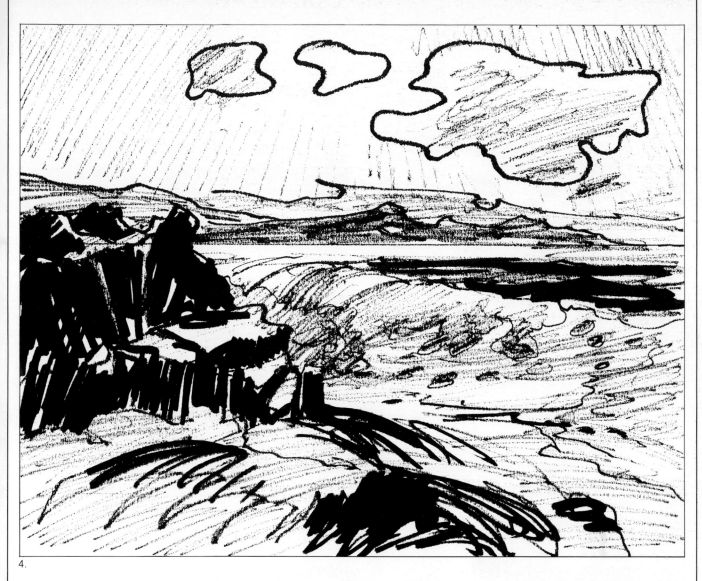

4.

the color, the time of day, and the overall mood. Then I take a number of photographs, concentrating only on the best features of rocks, foam, waves, and background. At this point I don't worry about their relationship to each other. I'll work that out later.

### COMPOSING

When the photographs are developed I place them with my sketches and work up a composition. The camera may have captured some features my eye missed, or I may have better ideas or a better feeling for the mood than the photographs show. In any case, I make a new sketch, rearranging the basic elements from my notes and photographs until I have a drawing that best expresses my feelings about that particular scene and mood.

For example, in reworking my sketch, I may choose to move rocks or waves or to change their size. Or I may choose to feature a different lighting or change its direction. This is artistic license and I feel free to rearrange a scene to satisfy myself, striving for compositions that are pleasing to the eye and to best convey the mood or feeling I had when I first confronted the scene. Remember, we artists don't just paint scenes. We paint moods, emotions, and a little of ourselves.

### COLOR

Next I check my notes concerning the color. Even though I'm anxious to begin the painting, I also take the time to work out the color scheme I believe will work best. Generally, I mix and daub the colors on a scrap of canvas with a painting knife. Since color carries mood, as well as line and value, don't be arbitrary in your choice of colors. You must select and combine those that best suit your feelings and convey the mood of the scene.

### STEP-BY-STEP DEMONSTRATION

This demonstration represents the approach of only one artist, me, and is only one of numerous possible ways I could have handled it. It is not the final word, nor is it intended to be. Technique, like creativity, is carefully nurtured and personal. While we can learn from others, we must still sift through all the data and come up with what is comfortable for ourselves.

I do not always use this particular approach. For example, I do not always start with the sky nor do I always use these colors. I believe that the scene itself, with its peculiarities and its effect on each individual artist, must dictate the final interpretation. Thus your technique may change from subject to subject. Since the best teacher is the subject itself, I recommend as much on-location study and painting as possible. You must train your eyes to see and your hand to cooperate in transferring your moods, your emotions, and your observations of nature to your painting.

*1. Rocks and Background.* This is a

5.

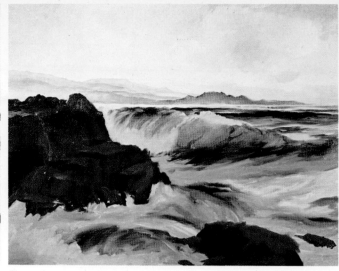

6.

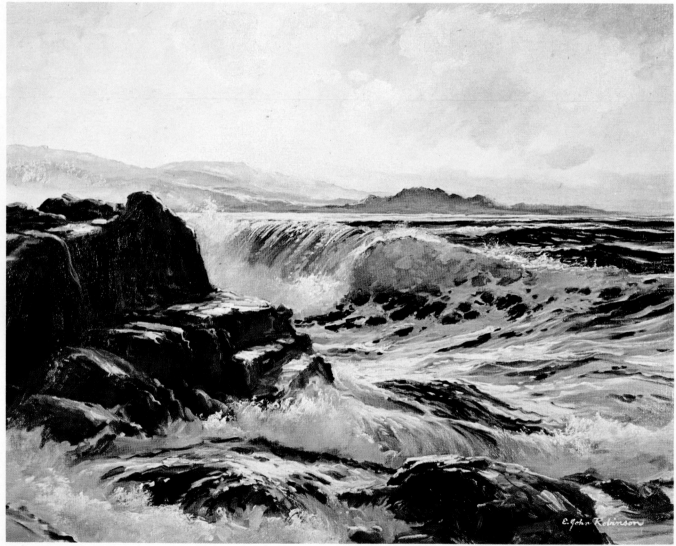

7.

black-and-white photograph I took of Point Lobos from Pescadero Point on the Monterey peninsula. I was especially taken with the rocks and the way the light fell upon them. (Notice the strong values and the surface textures.) As a composition, however, I find this photograph unsatisfactory. The biggest problem is the lack of a major wave, but there are other problems too. The foreground rocks are too close to the major rock, which gives too much weight to the left-hand side. Then, although the sea is foamy, it is rather flat—the sunlight is so strong that the values of the sea are washed out. In short, the scene clearly needs a major wave and a rearrangement of values.

2. *Major Wave.* At the same time I photographed the rocks, this wave was breaking only a few hundred yards away. But while the wave was exactly the size and shape I needed for my composition, the surrounding area was devoid of rocks or interesting background. But just because nature didn't line up the waves and rocks to suit me doesn't mean it can't be changed! By combining the best of both snapshots, I create my own composition.

3. *Outline.* After a couple of attempts, I finally settle on this linear arrangement of the composition. I believe it reflects the moods I felt, as well as the actual scene.

Notice that I include a little less of the large rock than appeared in the photograph, and that I have moved the foreground rocks to the right. This arrangement gives better balance to the dark rocks. I also add clouds in the sky to help form an overall circular composition around the wave. Since the wave is my center of interest and must command more attention than the rest of the composition, I place it so that it is ready to crash into the rocks.

4. *Value Sketch.* I now make a quick value sketch of the composition, which helps avoid many mistakes. I think in terms of three values: light, middle, and dark. (The in-between values will occur later as I'm painting without my even trying to get them.) I arrange the composition around a major value—in this case, a middle value. I next choose a dark value for the large masses, and finally add a small number of light values.

By carefully arranging the values, I ensure that my center of interest, the wave, will clearly be supported. That is, I have placed it against the darkest dark of the painting and backed it with the lightest light. Nowhere else will I use such strong contrasting values. Notice also that the dark masses—the major rock, the foreground rock, and the dark swells above the wave—form a loose triangle around the wave. Finally, I decide to place the sun above the picture and to the left of center to provide a down lighting and to frame the major wave. That was the way I had seen it originally and it was one of the elements that attracted me.

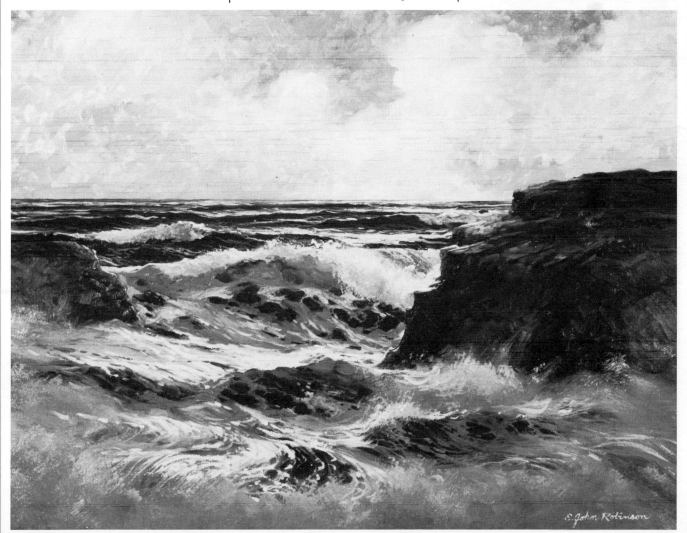

*Fall Weather,* 1980, oil, 24 x 30. Courtesy The Canyon Art Gallery, Canyon, Texas. In the summer, there is little, if any, wave action, so I gladly welcome back the action of the first fall storms. When I begin to notice that the waves have built up some size and froth and the once-blue sky shows that the weather is changing, I know autumn has come.

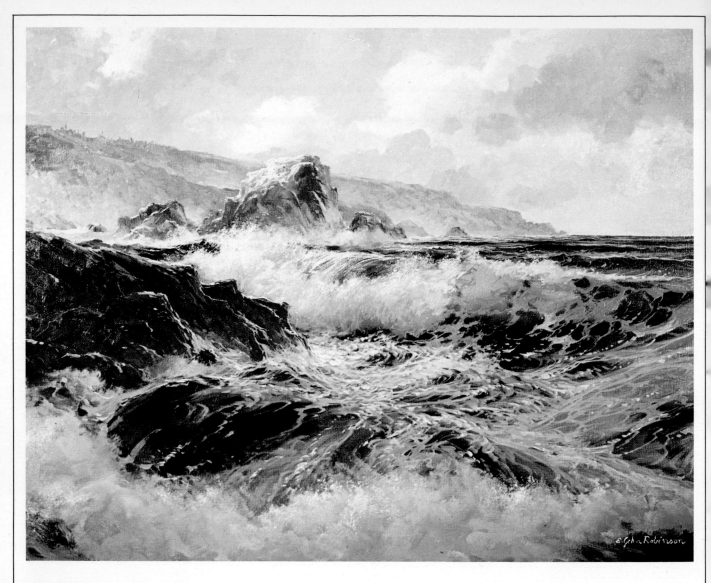

Above: *Winter Action*, 1980, oil, 24 x 30. Private collection. In the winter, the waves build high and thunder in, one behind the other. What were once calm, shallow-water inlets now boil with froth and spray. Anyone observing the sea can't help but feel its power and excitement.

Opposite page: *Mellow Sundown*, 1980, oil, 18 x 24. Private collection. On the Pacific coast, a sunset may be so strong in color that it changes the color of the sea. The sea reflects the sky and the atmosphere. It is also a mirror for mankind. It seems to reflect our moods, our emotions and, perhaps, our innermost thoughts.

These four stages in composing a painting are important to take to avoid problems later, but they're by no means meant to be a fixed blueprint. Even now I may still choose to change the composition. In fact, once I get started, I may have to make many unpredictable changes. Besides, if it were all totally preplanned, there would be no creativity. It would be just like painting by numbers, a mechanical chore. You need to leave just enough flexibility in your planning to ensure enjoyment.

5. *The Sky*. I paint the sky with manganese blue mixed into white. The lighter area is white with a touch of cadmium yellow medium. I use a No. 8 filbert bristle brush and whip the blue in first. Then I blend the yellow-white into the blue, giving the effect of sunlit mist. Notice that there is more blue and less white at the upper and outer edges and that the central area is much lighter.

I leave the clouds unpainted while I lay in the background sky so I can paint the clouds on top of it, in order to help the clouds appear much closer. With the same size brush, I paint the sunlit portion of the clouds next with white and a touch of cadmium yellow medium. Then I mix a lavender blue hue by combining manganese blue with a lot of white and a touch of alizarin crimson, and scrub it into the interior and shadow side of the clouds. Notice that I soften the shadowed edges by blending them slightly into the background blue.

Before I proceed to the next step, I scrub darker values into the rocks and waves, using pure viridian for the wave and raw sienna for the rock. Then I scrub in a bit of ultramarine blue to add more depth to the wave and deepen the shadow on the rocks. These steps give me a clearer picture of the values I'll be adding later.

6. *Underpainting*. With a No. 4 bristle brush, I paint the background hills with a mixture of manganese blue added to white, with a touch of alizarin for the lavender effect. The nearer hills are the same colors, with the addition of viridian.

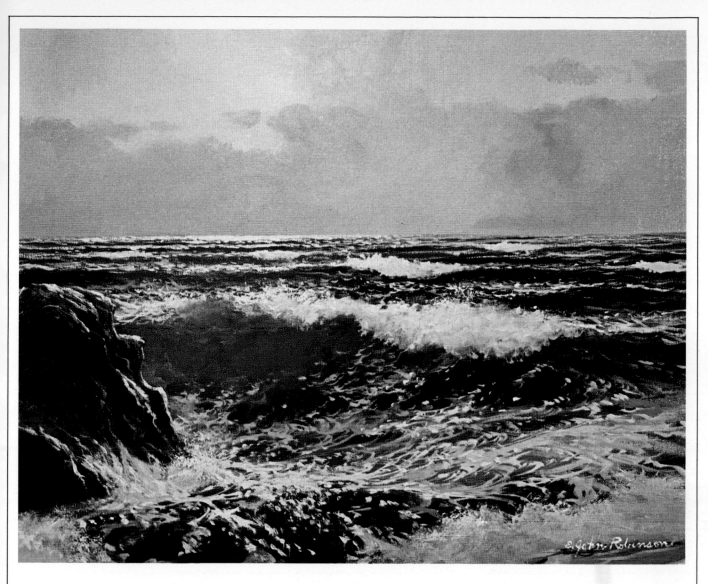

When most of the background is complete, I scrub in the underpainting of the remainder of the canvas. I go back to the No. 8 bristle so I can lay in the color quickly. As mentioned before, I use pure viridian for the wave, but add ultramarine blue to darken its base. To achieve the translucent effect of the wave, I mix lemon yellow into white and blend upward from the green, gradually adding more yellow-white and less green so the wave gradually changes from dark to light.

The rocks are underpainted with raw sienna and darkened with ultramarine blue. I also indicate some of the larger cracks with dark blue. Finally, I paint the flat surfaces and foreground with a darker version of the manganese-blue sky, darkened merely by adding some ultramarine blue to it, especially in the shadowed areas. Then I scrub more viridian into the foreground to show moving water.

7. *Atmosphere and Sunlight.* Atmosphere is really a combination of sunlight and sky colors. In this case, the sky was manganese blue mixed into white, and the sunlight was cadmium yellow medium added to white.

I applied the atmosphere first with smaller brushes—mostly Nos. 2 and 4 flat sables. Since any portion of water or rock that faces upward reflects the sky, I used the smaller brushes to place short, horizontal strokes of sky color over the flatter surfaces in the painting. Although I followed the contours and ridges of these surfaces, I ran the strokes in the direction of the major lines of movement.

I also painted foam patterns over the face of the wave with the darker surface shadow—ultramarine blue and white. The foam added interest to the wave, thus assuring its prominence in the painting. With a small brush, I painted around what now appear to be holes in the foam, adding some of the lower holes later as spots of dark green. The last and most careful step I did was adding the sunlight to this painting. It was also the smallest amount of paint I applied. Adding too much sunlight would have washed out the contrast I had intended. Again, the sunlight color was white with a touch of cadmium yellow medium. I applied it in much the same way as I did the atmosphere, with small brushes and short strokes. Remember, the sea reflects the light—and the more movement there is, the more shattered the light will be. I concentrated most of the sparkle on the sea behind the wave, with the remaining touches scattered in the foreground.

The finished painting, *View of Point Lobos* (1980, oil, 24 x 30. Courtesy The Canyon Art Gallery, Canyon, Texas), has the mood and effect I originally observed and tried to recreate. The weather is sunny but misty. The wave action is strong, and there is a feeling of movement, even excitement, in the air. ●

# SYBIL D'ORSI: SUNLIGHT CAPTURED

BY BARBARA GELDERMANN HAILS

2

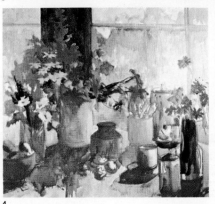

1

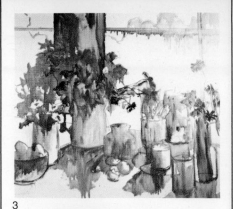

3

4

SUNLIGHT STREAMS THROUGH the canvases of Sybil D'Orsi, shimmering through lacy, verdant foliage and glancing off the vivid blossoms of casually arranged bouquets. The light dances off the tabletops, reflecting a warm glow into the shadow sides of bowls, crocks, and pitchers. Porcelain, pewter, and wooden objects lose their individuality in the haze of back light, becoming essential elements in a cohesive design. Flowers are everywhere . . . scarlet, fuchsia, and gold; even the shadows seem alive!

We first came across D'Orsi's paintings at the Capricorn Gallery in Bethesda, Maryland, a suburb of Washington, DC (D'Orsi's paintings can also be seen at the Blue Heron Gallery in Wellfleet, Massachusetts), where they literally arrest one's step. They are oil on large linen canvases in a style that D'Orsi describes as "realistic impressionism." In the midst of the clutter of a change of shows in the gallery, we were able to talk with the artist. Our first question was, of course, how did she achieve such magnificent light effects in her paintings?

To begin each painting, D'Orsi selects an assortment of still-life objects and places them against a window background that faces east at the end of her long, narrow studio. A bouquet of blossoms picked from her own gardens in New Jersey or wildflowers from the fields surrounding her summer studio in Massachusetts set the key for the painting. She loves sunlight, so she places the elements where the sunshine streams across them from the rear, creating patterns of blazing light and deep, transparent shadows.

Her studio is a long, narrow room (12' x 20') at the back of the house, a former porch that has been glassed in. One long wall of windows faces north, while the ceiling harbors four skylights—the only source of working light. D'Orsi uses the single east window for the still-life setup. She prefers an uncluttered studio, so, except for a large, double-standard easel and rolling cart with her glass palette, D'Orsi stores all spare materials, props, canvas, stretchers, and completed works in the basement. The resulting sense of space and light is clearly seen in her compositions.

In the still-life setup, D'Orsi arranges props from her collection gleaned through years of scavenging flea markets, garage sales, and friends' kitchens. "I prefer the random look of milk cartons, mustard jars, old bottles, coffee cans, old paint tubes, eggshells, and pots and pans to more formal objects," she says. The flowers deter-

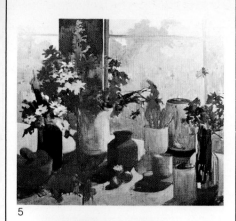

5

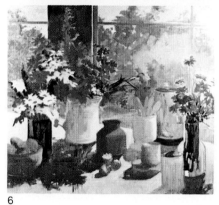

6

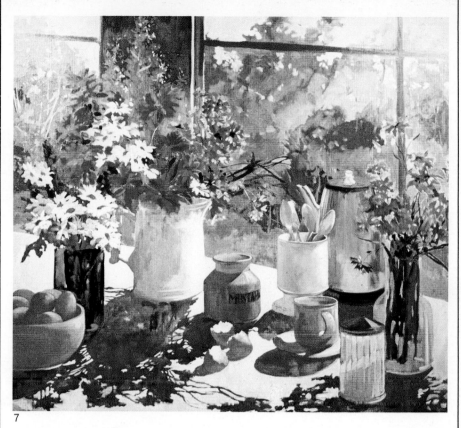

7

mine what type, size, shape, and color of props are chosen.

Rather than arranging the objects first and sketching afterwards, D'Orsi starts with the objects scattered on the tabletop and makes sample sketches on white drawing paper with a fine-point Rapidograph pen: "I try out various compositions, moving the objects about to see how they work in terms of light and shadow, putting a light value against a dark one where emphasis is needed, overlapping some objects to form a better design, and making sure there is a variety of shapes to lead the eye through the picture." Once D'Orsi finds a composition that works in the sunlight—decided by the most successful sketch—she moves the objects into a "final position" and takes as many as six Polaroid shots of the setup to "freeze" the shape of the shadows and lights (Step 1). "Painting in sunlight is difficult, because the shadows are constantly moving and changing," she says. "I make note of the time the sun was at the right angle so that I can go back to that time another day to check for shapes, colors, lights, and darks." D'Orsi views the setup through several small (roughly 5″ x 7″) black mats, cut to different proportions so that she can determine the best canvas shape for the composition.

She then selects a canvas from her stock. They are large, sometimes as big as 60″ in one direction. She frequently favors canvas sizes 36″ x 40″ and 30″ x 40″. She uses Anco heavyweight stretchers as the structural support, which are so sturdy that they require no cross braces. The canvas surface is always smooth, Belgian portrait linen, single- or double-primed, from Artists' Canvas Manufacturing Corporation. When using single-primed canvas, D'Orsi applies an additional coat of white lead or flake-white paint, allowing it to dry three weeks before painting on it.

"I start with a rough charcoal drawing on the canvas (Step 2), more for placement than for accuracy. If this seems to be working well, I dust it off and switch to a thin wash of turpentine and yellow ochre, applied with a No. 6 hog bristle brush to sketch in the composition," she says.

Using a No. 8 Grumbacher Series 4231 brush, D'Orsi begins to mass in the large areas of the painting in pigment thinned with turpentine to resemble a watercolor wash. "If you are working anytime from 10 o'clock in the morning (or 9 a.m. in the summertime) to 3 p.m., the light is cool, and the shadows will definitely be warm. In late afternoon, indoors, the reverse will be true, since the sun's rays, being

low to the earth, are long and hot," she says; for this reason, D'Orsi feels that deciding on the quality of the light is the most important decision in this initial color block-in stage.

D'Orsi's appreciation of light temperature dramatically affects her pigment choice. When the light is cool (as in the step-by-step), she makes her shadows warm, using yellow ochre, raw sienna, alizarin crimson, cobalt violet, and cadmium green light. Cool cerulean blue, cobalt blue, and viridian are used for the light areas.

D'Orsi begins her block-in of the entire painting with turpentine, keeping the Winsor & Newton pigments very thin. Her watercolor experience is invaluable at this stage, and she recognizes the direct inheritance of technique, except that white spaces are preserved in watercolor, and now she covers every inch of canvas with the colors of the final painting, but in a medium to dark color range. She says, "Allow the colors to run together, let the paint drip, and work as quickly as possible to cover the entire canvas with color. This is when you can go wild with color, mixing directly on the canvas instead of the palette. Pick up a fully loaded brush of two or three colors with turpentine and mass in the objects and its shadow in just a few strokes. If it is wrong, wipe it off with

*Morning Sun*, 1979, oil, 36 x 40.
Collection Mr. and Mrs. William
McWhiter. Here the artist set up a
random collection of props from
the kitchen by a sunny window. The
strong sunlight and glowing shad-
ows create an atmosphere of
warmth and peace.

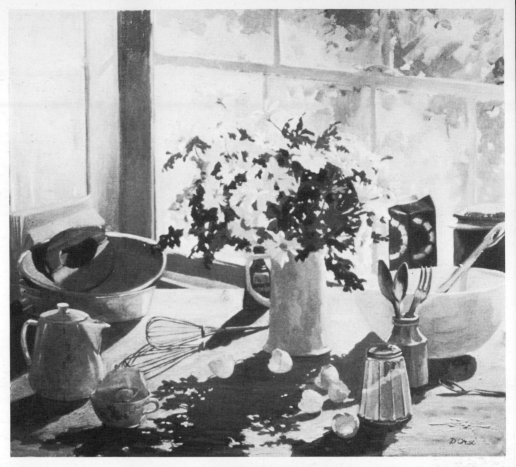

*Still Life with Cocoa*, 1980, oil on
linen, 24 x 25. Collection Mr. and
Mrs. Michael Rose. The light hitting
the blind, down the window frame,
and behind the flowers made an in-
teresting pattern of sun and
shadow for D'Orsi.

Opposite page: *Still Life with To-
matoes*, 1980, oil on linen, 30 x 36.
Collection Bruce G. Lundvall. ''For
this still life I combined old vases,
pitchers, baskets, flowers, and
vegetables for sale at Scases'
Flower Farm in Massachusetts,''
says the artist. ''Set on a tree
stump in a sunny field, they typify
summertime in New England.''

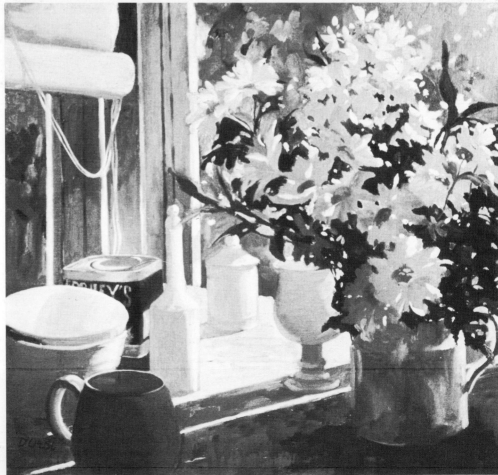

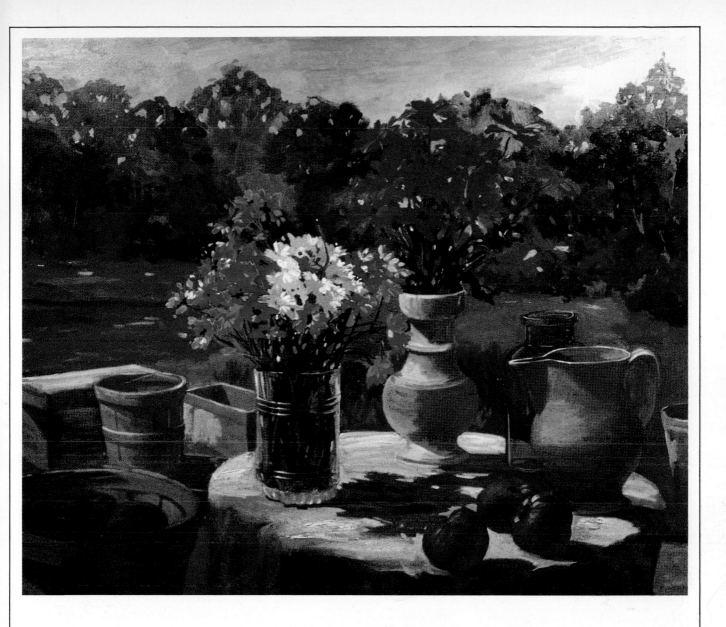

a rag and try it again rather than trying to make corrections on the canvas. At this stage, you are more concerned with the painting itself as a composition of large shapes, or patterns of light and dark, than as a representational copy of your model.

"It is important not to be locked into the small sketches. What works well in a 4″ x 5″ pen-and-ink sketch may not work in a 3′ x 4′ painting. So this is the time for shifting and moving objects around within the canvas to achieve the design you want."

She continues: "When the canvas is completely covered, it is time to stop, catch your breath, take a walk, and then take a fresh look from a distance. By squinting, you will eliminate details and show up the larger shapes." Adding the darks (Step 4) confirms the complete value range that will occur in the final painting.

Since the sun has moved on by now, D'Orsi waits until the next day when she begins again, but uses Winton Me-

dium for the middle stage (Step 5), still keeping the pigment fairly thin. She again avoids the lights, working in the medium to dark range of colors. "In order to show sunlight, you must show dark," she says. D'Orsi alternates colors, moving from dark to medium and medium to dark, back and forth, keeping the canvas wet. If any area dries out, the artist applies Winton Medium to the area with a finger. From the "Winton stage" onward, the painting is never allowed to dry. To maintain this desired state over several days, D'Orsi may find it necessary to wet the canvas as described, section by section with Winton. "The color of the object and its shadow often run together in value, if not in hue, and I do not separate them until the painting is almost finished," she comments. D'Orsi is careful to keep the edges of the flowers soft in order to preserve their character.

As D'Orsi approaches the final stage of the painting, she once again

changes her medium to one-half stand oil and one-half turpentine, a mixture which imparts a rich, "juicy" quality to the pigment. She also rearranges her palette (Step 6) for convenience, systematically mixing white with each of the following colors to achieve lighter values: cerulean blue, cadmium orange, viridian, alizarin crimson, cobalt blue, and yellow ochre. These light tones may then be picked up on the brush to obtain a range of subtle cool and warm grays which are not overmixed. She first attacks the lights on the tabletop and then the lights on the objects. "The more I approach the end of the painting," she says, "the thicker the paint gets. I save the thickest paint for the lightest areas. The hardest thing for me to do is to hold back from using the heavy paint until the end, because that's the delicious part!"

When the artist has completed the lights, she adds the darkest darks for accent, such as under a vase to sepa-

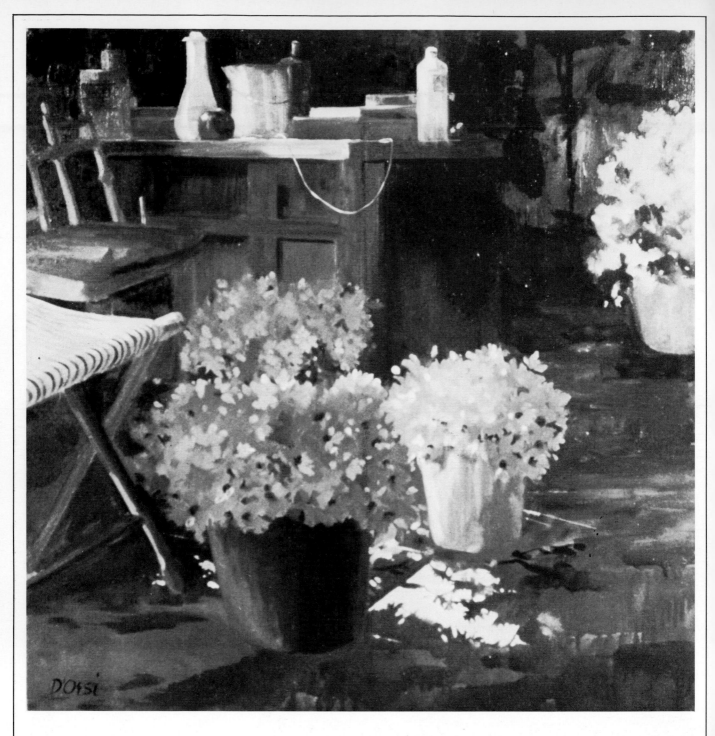

rate it from its shadow and to the interior depths of foliage. By applying a few of the lightest lights for highlights and being careful neither to use too many nor to break up the medium and dark masses, she completes the painting (Step 7: *Summer Morning*, 1980, oil, 36 x 40. Collection Mr. and Mrs. A. Grossman).

It may take D'Orsi as many as ten days to complete a large painting and satisfactorily capture the elusive sunlight and shadows. She works with determined discipline from 8 a.m. to 3 p.m. six days a week. She has reflected on this regimen and drawn conclusions about the creative energy cycle: "Painting is not one smooth step from beginning to end. I don't know anyone who reaches a point in a painting where he or she doesn't say, 'My God! Is this ever going to be right?'

"How do you save a painting when it starts to go sour? How do you get back that original freshness? Monday morning, you're full of inspiration; Tuesday, a little less. By Thursday, you are ready to slit your own throat, in spite of the fact that you are working on the thing that got you so excited in the first place.

"I'm not a 'downer,' but that doesn't mean I can't get low over a painting. As you get more experience, that mood comes over you less. You know what to do about it. I don't have the solution, but I'm sure getting there....

"You can psych yourself. Walk away from it; put it away; blank out certain areas; get rid of it for two or three weeks; go back to your original sketch; or go out and take a walk. There are things you can do besides tearing up the painting or throwing it away and feeling miserable. There are ways to plug on."

D'Orsi frequently works on three—and sometimes as many as five—paintings at a time at different times of the day. "It's not that I consciously say

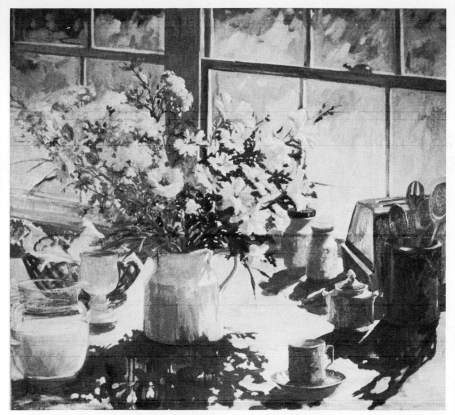

*Arrangement in Blue and White*, 1979, oil on linen, 40 x 36. Collection Mr. and Mrs. Stanley Mandel. D'Orsi captured the freshness of the blue-and-white flowers echoed in the crockery, the pitcher of milk, basket of bread, and sunlit window. An informal arrangement of simple props is made beautiful by the light.

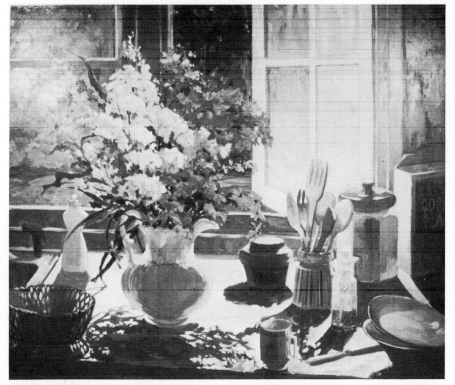

*The Open Window*, 1980, oil on linen, 50 x 42. Collection Mr. and Mrs. B. Swanstrom. The sun, streaming through the window on a spring morning, adds a glow to the familiar objects on a kitchen sink counter and gives a special life to the composition.

Opposite page: *Interior with Flowers*, 1980, oil on linen, 24 x 24. Collection Mr. and Mrs. H. Gannet. The artist used the subdued interior light of this painting to give it the look of an early Dutch still life.

that I'm going to stop on this one and start the next. I get to a point in a painting where it's wiser to leave it alone and come back to it later. That's when I start another one. Sometimes I come back to it and say, 'What was I doing here?' You keep the setup and psych yourself back into it. Sometimes I can't wait to get back to it and know exactly where I left off. It's just as if I never stopped," she says.

At the conclusion of a work, D'Orsi takes the time to critique her own work by moving it to a variety of locations and viewing it in different light situations, including incandescent indoor light. Any needed adjustments are made before the painting is considered finished. A Polaroid shot is taken of the piece and is kept in a card-file with pertinent information on it, including the title, size, gallery, price, and when it is sold, the name and address of the client are added.

D'Orsi's husband, Tony, does the framing, using a simple, two-part slat frame of one-inch clear pine which he designed. The first slat, slightly recessed, has been painted white, while the second has been left natural, protected with a coat of linseed oil. Both sections of wood are attached to the painting edges with handsome, visible brass screws.

D'Orsi's paintings are breathtakingly beautiful. Throughout her canvases the brilliance of sunshine and the glow of reflected light contrast with rich, transparent darks. The stream of dazzling back light imparts everything it touches with a special life, striking a responsive chord within the viewer. D'Orsi's subject is not just flowers. She uses objects she loves from around her home, along with a gathering of plant matter, to design an environment in which to trap the sun. Actually, her subject is light.●

# IMAGINATION IN REALIST PAINTING

BY GARY MICHAEL

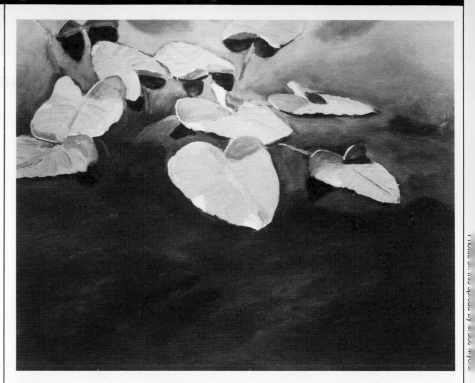

Right: *Lily Leaves and Fish*, 1981, oil, 16 x 20. Collection Mr. and Mrs. Arthur O. Wilkonson. The vegetation was painted on location in Wyoming. I added the fish in the studio in order to get another diagonal. When I showed the painting to a local gallery owner, his only comment was, "That kind of fish don't live in that kind of water!"

Opposite page: *Teton Lily Pond*, 1982, oil, 40 x 55. Collection Mr. Harold Spitzer. This is an arrangement in the studio of some of the elements encountered at Moose Pond, Teton National Park, Wyoming. The compound curve is a compositional device I find particularly appealing.

IMAGINATION IS more than an artist's best friend; it's his or her very *raison d'être*. In its absence, the artist is, no matter how skilled, but a reporter of what already exists, instead of a creator of fresh images. Imagination is a response to things seen, either at the moment or as memory presents them, and it responds in various ways.

Imagination enables us to combine ideas and images. Trees from one locale, hills from another, and a stream you may have seen in yet another can be brought together to form a whole new scene. Thomas Gainsborough would arrange lumps of coal, sticks, sand, glass, broccoli, and other things on his kitchen table. When he arrived at an interesting pattern, he used it for the basis of an imaginary landscape.

Whether you use broccoli or real bushes in your imaginary scene, you have to be careful to keep the angle and degree of light consistent. An overcast mood is easier to invent than brilliant sun because you don't have to deal with shadows, which are among the trickiest things to make believable in the absence of good reference. Some painters say you should include in your scene only such rocks and vegetation as are indigenous to the area depicted. I find this ethic too confining and concur with the painter John F. Carlson's policy: "If the trees before us are of a . . . mass or color that would impair an aesthetic completeness of our motif, we simply 'transplant' other trees of more com-

patible character into our picture." Of course, a scene with a palm tree in front of Pikes Peak might look a little silly. On the other hand, it might make a more provocative statement.

Several years ago, I did a 30"-x-36" oil that brought together trees from Wyoming and Colorado, barns and a shed from Tennessee (although they could have been from anywhere), and hills from Virginia. In a previous work, an 18"-x-24" pastel, the autumnal colors of the Colorado cottonwoods predominated, so I called it *San Juan Scene* after a southern Colorado mountain range. In the oil, much more importance was given to the verdant Virginia hills, so its name became *Appalachian Idyll*.

Another but related way imagination can serve as a source of ideas is by enabling us to reuse motifs or images that we have previously encountered. If we take the world as our workshop, it doesn't seem to me to matter whether the creative stimulus lies in nature, a museum, or photo magazine. Anything is a legitimate starting point (even someone else's painting) as long as it remains that—a starting point. Much the same can be said about references. The notion that there's something nefarious about referring to any photos other than those you have taken yourself is arbitrary. Glean whatever you can from wherever you find it, let your mind feed on it for a while, and then make of it something new. That it's not wholly new need not bother you; nothing

ever is. If you're satisfied that a transformation has taken place, that's enough. You have to be the ultimate judge of whether your art is what David Smith called "an act of personal conviction and identity."

A landscape I once saw in a Vienna museum dazzled me. I made a pencil sketch of it, indicated a few colors and values to refresh my memory later if necessary, and carried the sketch back home. In my studio, I did a small study much as I remembered the painting, with a little help from my sketch. Then that wonderful process called "play" began. My thought processes went something like this: Instead of these European trees, let's substitute pine and aspen. Some sage would look good in the foreground and so would more fall colors. Now, how about a big blue mountain behind the yellow-leaved trees on the right? Let's get some wind into the picture, break up those cumulus clouds into moving wisps of moisture, a portent of coming cold. Ah, but those yellow leaves are too close in value to the distant blue mountain; an evergreen behind them will solve that. Oh, no, the sap green is starting to take over; better break it up with some strategic hits of violet. Okay for the color, but now we need a diagonal to counter the direction of the cloud drift. Let's just slip a dead tree in by the evergreen and. . . .

By the time I finished, of course, it was a different picture, reminiscent of a different place and a different time of year—a new thing. Since it was of no place in particular, I just called it *Color Theory*.

Most of the really important things that happen to us are simply gifts that fall into our laps. After years of being influenced by too many people at the same time, I experienced something that caused those influences to meld; the many sounds coalesced, without any conscious effort on my part, into one.

The thing that happened to me was Moose Pond in Teton National Park, Wyoming. It's not marked on the park map. On the side road that leads to within 100 yards of it, there's not even a sign to tell you you're there. But my friend, Mel Fillerup, who knows the park like the inside of his cowboy hat, took me there. No inanimate motif has ever captivated me more: a large pond sprinkled with lilies and surrounded by tall grass and evergreens, an utterly idyllic environment. It was like Giverny in Wyoming.

At the time, I was unfamiliar with anyone else's treatment of the subject, save Monet's. Since my interests ran more to careful drawing and tonal pattern than his, he wasn't much help. So I began painting—small groups, large groups, and "vistas." The manner was unconscious and seemed for the first time to be totally my own. My métier had emerged. One of the paintings that resulted was *Teton Lily Pond*.

Since then, it's been much easier for me to do the same with other subjects. Having learned to ride one horse, you find others forever easier. From this we may infer that the best thing you can do for your style—true style, not just manner—is to leave it alone so it can happen. Remember the words of Degas: "Only when he no longer knows what he's doing does the artist do good things."

You, too, can paint as much or as little of a pond and its setting as you like. Zero in on a few leaves and trace their strange convolutions, or take on most of the pond, letting the lily masses arrange themselves according to your compositional impulses. What a plethora of elements to work with! Trees, quick and dead; their reflection, still or broken, depending on the

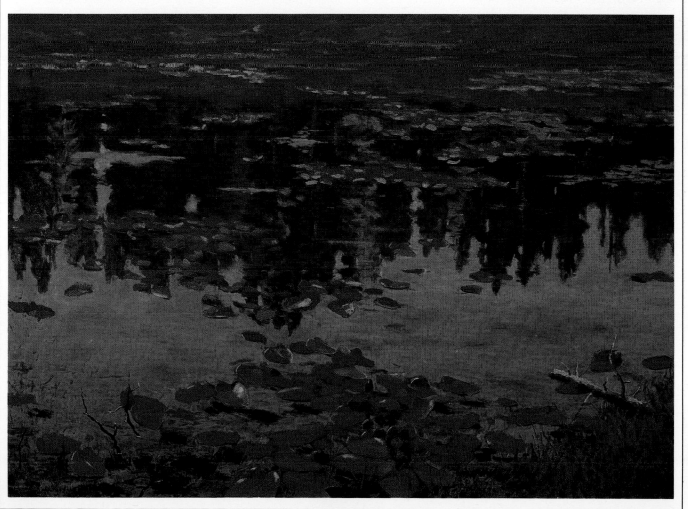

breeze; the sky's reflection; the lily leaves, blossoms, and stems; and the muddy bottom of the pond where you peer down into it. . . .

In the summer of 1981, a popular periodical did a story on sleep. The magazine cover showed a svelte brunette in different positions of somnolence between sky-blue sheets, which threw her long, dark hair into sharp relief. Now, there's a possibility, I thought. Suppose the sheets were white: there would be greater contrast to the hair, and the skin colors would really pop. Of course, more skin would have to show. The degree of exposure would be one of the best sources of variety for several works with the same theme. Another would be different body positions. Still another, the way the hair fell. Determining how much of the body should fall within the picture frame and how the folds and wrinkles of the sheets would change, both top and bottom, were other considerations that would lend variety. The one constant, besides the model, would be my angle of view: directly above the subject. Therein would lie the most interesting possibility of all for variety. The paintings, intended as a series, could be hung vertically or horizontally, with the model's head toward either the bottom or top, as the exhibitor chose. The grouping itself could be altered periodically to suit one's whimsy.

How easily that idea came because of a chance encounter with a magazine. Implementation was another matter. Not for a year and a half did a suitable model appear. Then there was the problem of the low ceiling in my studio. Even with my head pressing plaster, I wasn't far enough from the floor to gather the necessary reference, either graphic or photographic.

The solution was obvious, but complex. From two wooden crates, a small desk, and a ladder four feet high, I built a platform. I placed one end of a large, framed mirror (facedown) on top of it; the other, on some molding over the studio door. The model's "bed," a sheet on the carpeted floor, went under the mirror. There lay the model. I lay beside her, drawing and photographing her mirror image. Awkward to be sure, but of no consequence compared to Michelangelo's upside-down labors in the Sistine Chapel. The result was the painting *Chris Asleep.*

However valuable photos and paintings might prove, it's to life we must go at some point if it's life we want to paint. For life itself, animate and inanimate, is the primordial fount of inspiration. Transform it as we will, it is life that we, as representational painters, always try to evoke. As the painter Edgar Payne said, "Nature suggests ideas for interpretation; the artist supplies ideas of how the interpretation is to be made."

I like many forms of life and have resisted the good counsel to settle on a single subject because it would make my work more marketable. If you stop painting what you want because art marketers tell you it's bad for business, as an artist you've sold your birthright. If something stimulates you visually—be it flower, fence, or female—and you yearn for that unique visual interaction that can be provided only by painting it, paint it. Our great art heroes were versatile. They came, they saw, they painted—what they wanted to, not just what some well-meaning advisor urged them to do, as a way of solidifying their public image. Author-artist Henry Poore

Above: *Double Arch*, 1981, oil, 24 x 30. Collection the artist. Photo by Bruce Myers. I painted this from drawings done in Arches National Park, Utah. The design scheme could be called a compound circle.

Left: *Arizona Mansion*, 1977, oil, 9 x 12. Collection Mr. and Mrs. Bill Banta. Photo by David Sumner. While staying with friends in Paradise Valley, I set up my easel next to their pool and painted their neighbor's house.

made the case succinctly: "It cannot be denied that many artists making a success in a limited range of subject consent to stop, and go no further, under pressure of dealers or the public. The demand for specialists has much more reason in science and mechanics than in art, which is or should be a result of impulse."

Travel, for its own sake and for fresh visual stimuli, is a great joy. Life manifests itself differently in different places. Exploring a part of the world you've never seen before is a special thrill, especially for artists because they're more sensitive to subtle color and strange shape. One of the most amazing places I've ever been to is Arches National Park in Utah. My painting *Double Arch* is based on an arch of that name and an approximate shape I saw there. To achieve a variety of negative space, I found it necessary to take some liberty with nature's architecture. That was the easy part. Taking a lot of liberty with the color to get some snap was another matter. The line between snappy and gaudy is

like a chameleon—now you see it, now you don't. I'd rather err on the side of excess than fail for fear of offending someone. So I let loose with color, capturing the Utah sandstone at its most flamboyant. It was a case of using color to create (I hope) a sense of my excitement at seeing Double Arch.

The painting supplies I carry depend on the type of trip I'm taking. If it's exclusively a painting trip, with room in the car for large panels and a French easel, oils are my choice. But for the kind of trips I've taken to Europe, where *everything* has to go into a backpack, I take pastels. Twenty to 30 sticks are all I need. A little watercolor rig is almost as light, but watercolor is harder for me to control, and on a humid day the drying time torments me. Pastel is good in all weather; also, it's tractable and doesn't require any drying time or use of brush or medium. It lends itself more readily to vignette than other media, perhaps because it's a drawing as well as a painting medium. Its only serious limitation is the time it takes

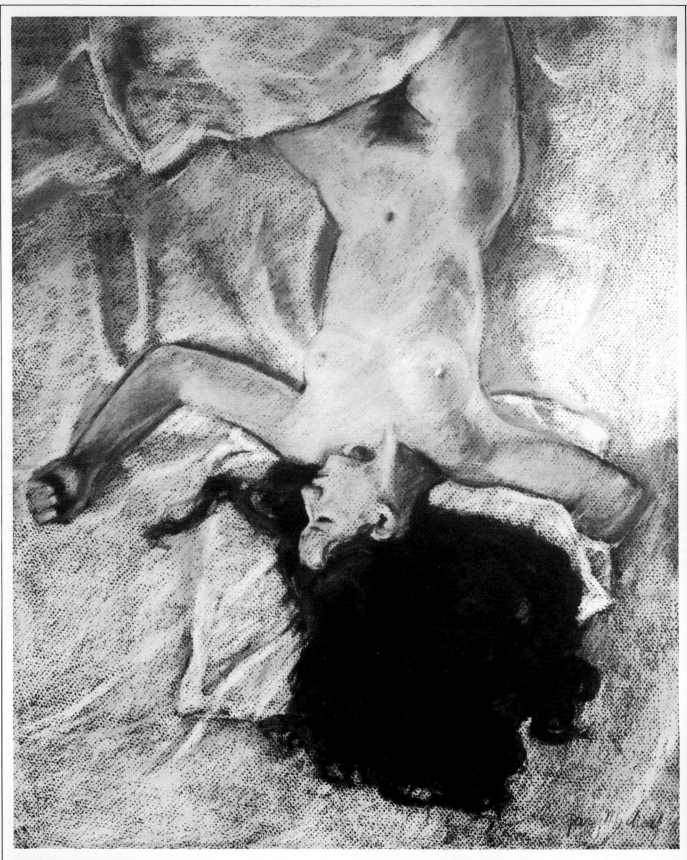

*Chris Asleep*, 1982, pastel,
20 x 16. Collection the artist. Photo by David
Shuler. This is one of a series of four nude
studies of the same model painted from the
same angle. The others in the series depict
her in different positions.

*Appalachian Idyll*, 1980, oil, 30 x 36. Collection Art and Carol Biddle. Photo by Tom Cox. The green hills of the Blue Ridge Mountain Trail inspired this transformation of a western Colorado scene.

to fill up large areas with color. But we're talking about suitability for small format. An 8″-x-6″ pad of toned paper and a similar-size box of chalk suffice.

Whatever the inspiration behind your work, it is not always easy to express your ideas. A late Rembrandt is ultimately more exciting, although hardly more beautiful, than a Vermeer or Whistler, from which all signs of effort have been removed. In Rembrandt's work, we get a glimpse of the interaction between artist and Muse, the heroic reach of the former and the inspiring force of the latter, rather than the consummate conquest of the artist, however magnificent it may be.

There's a story in Genesis about a wrestling match between Jacob and an unidentified man (in the revised standard version). The story can be taken lots of ways, and at one level it speaks to the artist. The mysterious man is the Muse. We wrestle with him in our struggle to give expression to our ideas. And through the struggle, if it is steadfast, we obtain his blessing. •

*Gary Michael resigned a professorship in 1973 to devote himself fulltime to painting. Since then, he has won numerous regional and national awards, including the Popular Vote Award at the 1979 annual exhibition of the Pastel Society of America. Michael, who holds master's degrees in philosophy and English and a Ph.D. in Humanities, is listed in* Who's Who in American Art, *has served Grumbacher as an official demonstrator, and contributed articles to* American Artist, Southwest Art, Colorado Quarterly, Palette Talk, Today's Art and Graphics, *and several newspapers. He is a popular lecturer and periodic TV actor, who also gives demonstrations and workshops. His work has previously appeared in* Southwest Art, Palette Talk, Art West, Art Voices, *and* Colorado Homes and Lifestyles *magazines and can be seen in the new book* Contemporary Western Artists, *by Harold and Peggy Samuels.*

*Michael was born in Denver, Colorado, and lives there still.*

# THE COLORIST APPROACH TO OIL PAINTING

BY LEE SEEBACH

*Lee Seebach was born in Waterloo, Iowa. He is a graduate of the American Academy of Art in Chicago, where he studied with Bill L. Parks, Joseph Vanden Broucke, Douglas Graves, and Irving Shapiro. Now living in Phoenix, Arizona, Seebach paints landscapes, figures, still lifes, and commissioned portraits.*

*He is represented by Fagen-Peterson Fine Art, Inc., in Scottsdale, Arizona.*

M**Y APPROACH** to painting, whatever the subject, is primarily based upon the observation and expression of the color transitions inherent in the subject before me. I analyze and paint my subject in terms of color areas to create the illusion of what I see. This emphasis on color leads naturally to a strong, painterly statement in which the various color areas combine visually to create a desired effect.

In the "colorist approach," a high premium is placed upon the painter's ability to identify accurately the colors in the subject and to translate those colors into paint. It requires a considerable amount of sensitive, careful, and patient study of nature, a thorough working knowledge of the possibilities in color mixing, and a great deal of experience in applying color to canvas.

Nature presents an infinite variety of subtle color variations. The challenge of capturing these endless color effects has led me to exciting discoveries in my work. Through the colorist approach, I have developed my ability to see and paint the colors of nature, which allows me the capability to express nature's variety in paint.

While I consider the other elements of fine painting important—accuracy of drawing, control of edges, unity, technique, line, composition, etc.—the use of the possibilities of color remains my primary interest and means of expression.

The major difference between the colorist approach and other approaches lies in "seeing." The subject is seen as interlocking areas or shapes of various colors, rather than as objects or things. When these colors are faithfully and expressively transposed onto the canvas, the result will represent the subject. This difference may seem very subtle, but it is very important in my work because it forms the basis of my approach.

For study purposes, I make many rapid, outdoor color sketches in oil on 12"-x-16" panels. I rarely cover the entire canvas. "Finish" and detail are not very important in these small studies, but accurately noting the colors *is*. The idea is to study how colors come together in the subject and on the canvas. My studies of this kind are very often rough and crude. My goal in doing them is to establish color relationships quickly for increased understanding, not to produce finished paintings. I discard most of them, saving only those to which I may want to refer later.

The step-by-step demonstration that accompanies this article illustrates a typical procedure I use in my larger outdoor paintings. Before I begin painting a picture, I always take a few minutes to study the subject and determine how the various areas of color should be distributed over the surface of the canvas. Once I have formed a mental picture of this distribution, I then determine the most logical blocking-in procedure.

Opposite page: *The Gibson Grocery—Jerome* (Arizona), 1982, oil, 20 x 24. Collection the artist. This painting, which is primarily a portrait of a fine old building and its surroundings, is also a study in perspective and geometric shapes.

Left: *Sheep's Crossing From the Verde River*, 1982, oil, 22 x 28. Collection the artist. Here I tried to capture the warm, early morning sunlight and the cool shadows on the bluffs. I set up my easel at precisely the same time for two mornings.

Below: *An Old Ford in Sunlight—Jerome*, 1982, oil, 22 x 28. Collection May Cheney. The effects of the intense, direct sunlight on this old truck offered an excellent opportunity to use a full range of values and a wide range of warm and cool colors.

*Old House in Jerome*, 1982, oil, 20 x 24. Collection Susan J. Apley. Here I tried to create the effect of sunlight with relatively few contrasting shadow areas. The overall high key of the scene, with reflected light bouncing in every direction, presented an interesting problem.

**Step 1.** To begin the painting *Houses and Trees—Jerome* (right), I applied thin turpentine washes of cobalt and ultramarine blue over the entire sky area, and yellow ochre and ultramarine blue in the tree area in the middle foreground. In the immediate foreground, I applied a thin wash of yellow ochre, into which I added mixtures of chromium oxide green, ultramarine blue, and Venetian red. I then established some of the dark areas of the buildings and washed in the bare tree, using varying mixtures of Venetian red, raw sienna, and ultramarine blue. At this stage, all paint applications were kept thin and transparent so they would dry quickly and not interfere with the opaque painting that was to follow.

It is very important to begin with correct color washes so that opaque color applied later can be accurately judged against them. The painting axiom "One false note leads to another" is important to bear in mind when beginning a painting. However,

if I have any doubt as to the correctness of these initial colors, I find it is better to exaggerate their intensity *slightly*, rather than to understate. I do this for three reasons: 1) color errors are more easily detected and therefore corrected, 2) some of these areas may be allowed to show through an application of dry brushstrokes in order to create a lively, vibrating effect, and 3) it is not my intention to copy nature slavishly, but to express my feelings about what I see. Exaggeration sometimes helps to express these feelings.

The ideal is always to set down the right colors from the very beginning. However, in the early stages this is not always possible, because the surrounding areas of color have yet to be applied.

**Step 2.** Next, I painted in the darkest shadow areas on the buildings and the bright light on the roof (using opaque paint) to establish the range of values.

I then applied opaque color in the sky area. Because the sky is "behind"

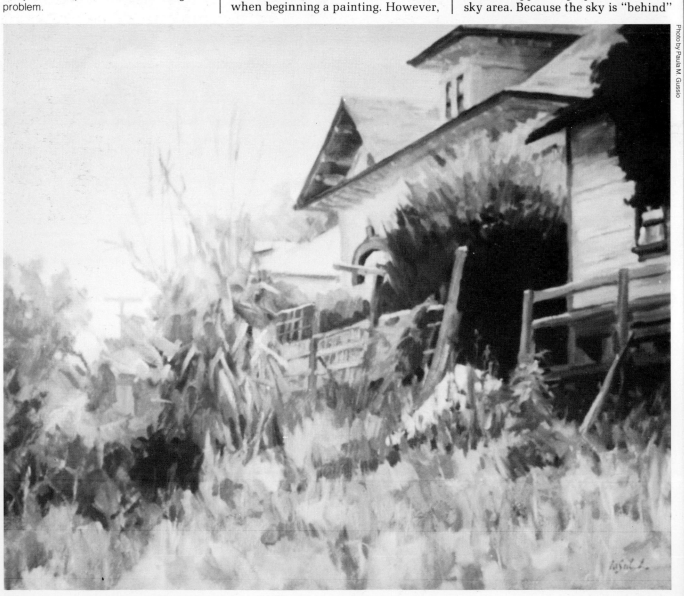

Photo by Paula M. Gussio

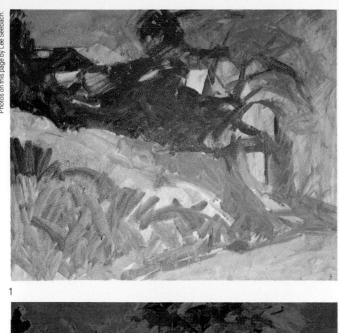

1

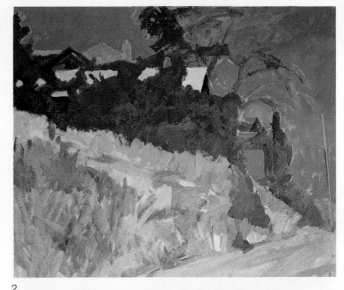

2

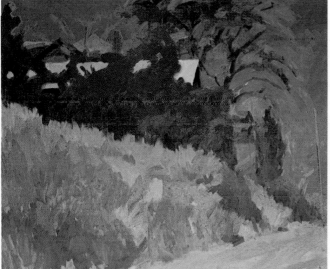

3

4

every other element in the picture, subsequent applications of paint on top of the sky helped achieve a three-dimensional effect.

Where the sky meets the building and trees, I brushed less pigment into these areas in preparation for subsequent paint applications.

I then moved to the tree area in the middle foreground and painted in the light and shadow areas. I finished this step with opaque paint in the foreground area by beginning to indicate some of the color patterns there.

**Step 3.** My general procedure from this point on was to work in nearly every area of the painting in order to bring the entire canvas to completion as a whole. I paid more attention to painting the bare tree against the sky and the light on the middle foreground trees and to bringing the foreground nearer to a finished state.

**Step 4.** Of particular interest during this final stage was the painting of the distant tree. Rather than painting each branch individually, I treated the branches as simplified silhouettes of color against the sky. These colors had to be observed and painted very carefully so that they would not be painted too dark.

The finishing strokes were applied in the foreground where the complex mass of weeds and grasses was simplified into expressive patterns of color. The completed work: *Houses and Trees—Jerome*, 1982, oil, 20 x 24. Collection the artist.

Throughout the development of this painting, as in all my work, I used direct painting techniques, applying the paint in such a way as to achieve a fresh, decisive, and spontaneous appearance.

I usually stand at arm's length from my canvas and hold my brush as far back on the handle as possible. This stance gives me an overall view of my canvas as I work, allowing me to observe the development of a painting as a whole. To gain an even greater perspective of a work in progress, I frequently step back from the canvas to a distance of about seven feet, which is a normal viewing distance for an average-size canvas.

The majority of my work is painted from life. Actually experiencing the subject firsthand is essential for capturing the subtle colors of nature. I do, however, sometimes use photographs as an aid in recalling detail.

My outdoor palette is a 16″-x-20″ piece of Masonite, spray-painted a neutral mid-tone gray enamel and coated with a clear shellac which is impervious to turpentine and oil paint. A palette prepared in this way provides an excellent surface on which to mix opaque paint because of its neutral tone and color.

I squeeze my colors onto the palette in the following sequence to simulate

the color wheel (from left to right): Permalba white, cadmium yellow light, cadmium yellow deep, cadmium orange, cadmium red light, alizarin crimson, yellow ochre, raw sienna, Venetian red, burnt sienna deep, ultramarine blue deep, cobalt blue, phthalocyanine blue, phthalocyanine green, viridian, chromium oxide green, and ivory black.

For my figure and portrait work, I add burnt sienna, burnt umber, cerulean blue, and portraitist John Howard Sanden's Pro-Mix colors.

The brushes I prefer are filberts, all in even-numbered sizes, from Nos. 2-12. I also use three triangular painting knives, with blades measuring one, two, and three inches in length.

I rarely use a medium, since I do not particularly care for the smooth, even paint surface it tends to produce. The only additive I consistently use is turpentine, mainly in the beginning stages of a painting when I want to create transparent darks or semi-transparent and/or thin wash effects in preparation for opaque painting techniques.

For the artist, growth is a vital part of life. The greatest benefit of the colorist approach is the unlimited growth it offers the painter who approaches a subject with openness and sensitivity.

Every subject that nature presents is unique and calls for its own particular solution to the problem of painting in terms of color areas. In striving to express him- or herself through nature's infinite variety, the artist broadens his or her understanding of both nature and painting. This process opens the way to even greater painting possibilities, and the painter continues to grow and move into new, exciting realms of artistic expression. ●

Above: *Old House and Sumac Trees—Jerome*, 1982, oil, 20 x 24. Collection the artist. Besides being a study in greens, this scene presented the problem of how to paint the sky as it peeked through the sumac trees. It seemed hopeless and senseless to paint every ''skyhole,'' so I simplified the pattern into accurate, but less complicated, color areas.

Left: *Loy Butte*, 1982, oil, 22 x 28. Collection May Cheney. In this two-hour painting from life, my goal was to capture the effect of the low-hanging clouds as they enveloped the distant butte. Here, I was very conscious of making the red hills "stay in the distance." To achieve a feeling of depth, I contrasted the warmer red tones and the detail in the foreground against the cooler tones and simplicity of rendering in the hills.

Below: *An Old Tree*, 1982, oil, 22 x 28. Collection the artist. This huge, old tree, with the sunlight coming from behind it and to the right, was casting interesting shadow patterns on the sand. I was most intrigued by the variations of color in these shadows and the rough bark on the tree. I had to work fast during two painting sessions in order to capture these effects of light before they changed.

# PAINTING WITH WATER- COLORS

BY JEANNE DOBIE

Have you ever thought of watercolor as being a medium of both *paper* and *paint*?

When I ask students, "What is the strongest element in a watercolor?" the usual responses are: spontaneity, technical control, a strong dark design. While these are desirable qualities, they seldom think of the simplest element of all—leaving white paper *white*! However, a little investigation on their part reveals that the eye quickly picks out beautifully designed areas of plain white paper.

These white areas tend to gain attention more quickly than boldly painted darks owing to the transparent quality of watercolor, which allows light to pass through the pigments, reach the paper, and then reflect back. Naturally, the areas left untouched or thinly covered reflect or "glow" more than do heavily painted areas, which obstruct the passage of light. As a result, the eye of the viewer goes first to these "glowing" light areas. Because of its importance to the finished watercolor, I stress the idea of working with white from the beginning of a class.

Seeking the light pattern as a first priority is often a new approach for artists who use other mediums, such as oil, in which lights are applied during the process, or overlaid on previously painted areas. Beginners, too, forget to save white paper as they become mesmerized while creating watercolor effects. They find, too late, that they have completely covered the paper.

To counteract these tendencies of beginners and artists who are basically non-watercolorists, I have devised a simple "torn paper" project that fosters a respect for the white of the paper. The exercise isolates light areas from the rest of the composition so they can be analyzed, adjusted, and arranged into the best possible pattern before beginning to paint. After all, if the viewer's eye is drawn first to the light areas of a painting, shouldn't the artist treat it as something distinctive?

An interesting light pattern begins with the shapes that will eventually form that pattern. To develop a clear idea of the light areas in their composition, I ask students to tear or cut shapes from paper that correspond with the white areas and place them on a neutral gray cardboard. I urge them to include all the white, half-white, and generally light shapes they

see. Beginners sometimes miss out on potential patterns by failing to see all the light shapes they could put in a composition. For example, if the composition included a bouquet of white flowers in a vase, they would easily see the obvious area and tear out only one white shape—the flowers themselves. And that would be the extent of their pattern. A three-dimensional "light" box I constructed helps to show students light shapes in surrounding areas that may complement the subject.

The "light" box is an ordinary open box (about 6″ x 6″) turned on its side with a "window" cut out from the rear (see No. 1, below). In it, I positioned a painting of a vase of flowers. When the "window" of the box is held up against a light source, the direct rays of light are interrupted by the inside flowers, causing a variety of shapes to appear on the surfaces around the flowers and vase. Tilting or turning the box produces new light patterns on the walls, windowsill, and the foreground, as the direction of the light rays changes. Seeing shapes of light that supplement the primary subject shape is the goal.

In addition to shapes created by natural light, the box enables me to show that other whites can be placed in a composition to complete a pattern. I place a cut-out fallen flower in my boxed still life to demonstrate this. Moving the unattached flower around conveniently illustrates how it is possible to continue or add a pattern of light areas.

Using the box complements the torn paper exercise by increasing the students' awareness of the many light choices available. A second look at their landscapes or still lifes reveals light areas throughout the compositions, not just in the subject.

Returning to the torn paper project, they proceed to tear paper facsimiles of all the light shapes possible which will give them the tools to build an exciting pattern. Since the shapes are divorced from other influences in the composition, students are able to push them into patterns (see No. 2). The torn shapes can be combined, made to flow, or blocked into a solid group. As students examine the pieces in a village scene, for example, they may decide their rooftop shapes make up a distinctive light area, if two or more are merged. Combining several torn shapes in this manner often produces a silhouette with more angles and variety than would be found in one shape or rooftop.

Students may become overwhelmed by too many torn pieces scattered across their board. But even these random shapes can be easily organized. In fact, this is often an oppor-

5. *La Bretagne*, by Jeanne Dobie, 1979, 22 x 15. Collection the artist.

tunity for me to point out that they can utilize the natural lighting in their landscapes to suggest a flowing pattern. For instance, the student can gather the strewn shapes and make them echo the light crossing over a field, traveling up the side of a house, reappearing on a tree trunk, and coming to rest on a picket fence. This encourages the eye to move smoothly around the composition, following the light areas, instead of jumping abruptly from one scattered light piece to another.

Finally, the student might develop a forceful pattern by tying white shapes into a solid group. By joining one light shape to another, and yet another, for as long as he/she can continue, the student will build a dominant mass. Since the sheer size will command attention, the pieces are maneuvered to make the shape attractive.

It's obvious to see how effortlessly adjustments can be made by working with torn pieces of paper: one can move the experimental shapes to the right or left, up or down; one can even retear pieces, or lengthen, reduce or reshape them, combine them, or eliminate one here or there. Most of all, one can try different placements within the composition until a well-designed relationship is achieved.

When satisfied with the shapes and their arrangement, the students draw or transfer them to watercolor paper. I remind them that for the greatest impact, these areas must be left untouched as they paint. Under no circumstances should they submit to the temptation to cover them, consequently losing their brilliance. Adjusting white areas should be done after the painting is completed, when a

6. *Godchild*, by Jeanne Dobie, 1974, 22 x 30. Collection Monique Klaus.

gentle wash is all that is necessary to tone down an overly potent white.

If the student likes the result obtained by this process, he/she may choose the same discipline for distributing dark shapes. But this time, he/she should place the dark areas so that they complement the light design (see No. 3). Like magic, the darker additions further heighten the light shapes. As the remaining mid-tones are added, the "glow" of the white paper increases. Finally, as the painting is completed, the light pattern "emerges," a beautifully designed target that is the end result of the "working with white" exercise, and which is seen in my work *Fleeting* (see No. 4).

With this project, there's little chance of white paper being arbitrarily left or being finished with a ho-hum, nondescript light pattern. And how flexible the light shapes are when working with torn paper! Imagine the difficulty the students would encounter adjusting a light pattern as they paint or attempting to reclaim white paper after the watercolor is completed. Knowing before they begin that their light design, like the sculptor's statue, will not be chipped away and lost, may give them the confidence to enjoy their new medium of paper and paint! ● © 1979 Jeanne Dobie

**Jeanne Dobie** *attended the Philadelphia College of Art in Pennsylvania (then the Philadelphia Museum School of Art) and won several scholarships while there. On the faculty of Moore College of Art in Philadelphia, she has taught watercolor workshops coast-to-coast and abroad. She is a member of both the American Watercolor Society and the National Watercolor Society. Among many other exhibitions, her works have been shown at the National Academy Annual 1979 and Watercolor USA. She was a prizewinner at the 1979 Inveresk National Watercolor Competition and a recent recipient of the 1980 AWS High Winds Medal. Listed in Who's Who in American Art, Dobie is one of 16 artists featured in the book Watercolor, The Creative Experience (1979, Van Nostrand Reinhold).*

# A CLASSROOM APPROACH TO WATERCOLOR

BY IRVING SHAPIRO, A.W.S.

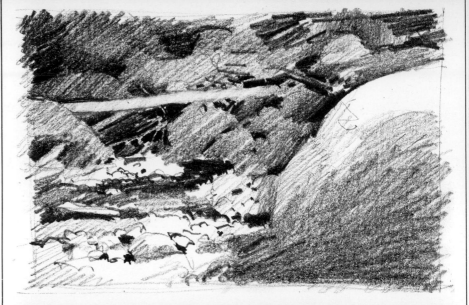

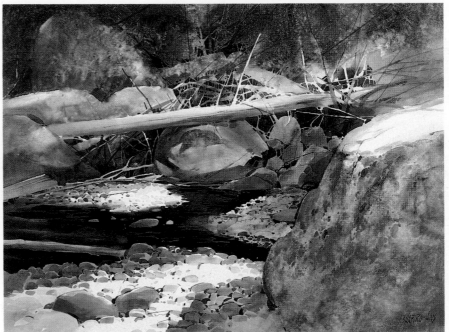

Top: Value study for *Shapes*. Center: *Shapes,* 1980, watercolor, 24 x 32. Courtesy Everett Oehlschlaeger Galleries, Chicago, Illinois. Shapiro found the combination of mammoth rock and the delicate patterns of filtered light irresistible as a display of nature's vagaries. Says Shapiro: ''The largest possible design of intermingled color and value was painted first, giving my attention to the inclusiveness and flow of shape, rather than to the individuality of the various forms.''

Opposite page, above: Value study for *Fields Full of Mysteries*. Opposite page, center: *Fields Full of Mysteries*, 1981, watercolor, 25 x 32. Courtesy Everett Oehlschlaeger Galleries, Chicago, Illinois. ''The entire painting area was first wet with a sponge, and I then quickly swept in the large passages of color, with special attention being given to the relationships of dark and light,'' says Shapiro.

WITH A LARGE SUPPLY of sharpened pencils and a sketch pad that doubles as my notebook, I began to write these words, intending that they be instructional. After some moments of trying to decide where to begin, I realized that I might best start as I would in the studio-classroom with my students. I've always tried to teach in a manner that would be an interlacing of the hows, with heavy doses of the whys.

With your forbearance then, I will precede my classroom-type of instruction with some comment of a philosophical sort that I feel will help provide the necessary atmosphere in which a painting can, perhaps, become a spirited, personal commentary.

Although I have chosen water-soluble pigments as the vehicle that will provide a visual expression of my hoped-for painting goals, the physical properties of color (be they water-soluble or otherwise) are of less-than-primary importance. The qualities and messages that we painters present on our two-dimensional surfaces—paper, canvas, fiberboard, or whatever—will reflect our abilities to relate whatever might be our intended statements. The word *painting* encompasses our total involvement. As watercolorists, however, we have identified ourselves as those committed to the wondrous excitements

promised by the properties of our particular medium. If painting is a jewel, then we, as watercolorists, might think of our medium as being the facet that lends the most dazzling luster to that gem. As watercolorists, we add the flavors that I, and every watercolorist that I know, feel to be magically special—often elusive and exasperating, but always enchanting.

Let's get down to the matters that I feel are the academic essentials of painting. From the first session that I spend with my students, I underscore the importance of a highly refined craftsmanship and a developed awareness and knowledge of our materials, their properties, allowed latitudes, and limits. Also emphasized are the traditional skills that must be cultivated to the highest degree possible, lest the resulting effort be transient and consigned to the vast area of trivial decoration. What must be stated as the quintessential element of craftsmanship is the ability to draw. To some, this would mean that the quality of drawing lies in the painter's ability to define objective content in a literal fashion. Yet this, although it is fundamental to the art of draftsmanship, is but the *beginning* of the drawing skill. The artist's interpretations, thoughtful departures from the fact, and finely honed judgments—these qualities will take the ability to draw to pulse-quickening levels. They direct the painter's decisions as to what is to be *done* with an objective fact other than imitating it.

The painter who is depicted as drifting with divine guidance into free-spirited, unfettered, inspired bursts of creative wonder is found only in Romantic fiction. More genuine are those who are blessed with the capacity to create and who become artists by nurturing their skill development, gaining experience, and pursuing their dedication to their craft, all of which provides the leverage and impetus for limitless, and credible, painting possibilities.

So, in my paintings that accompany this article, you will see drawing that not only identifies subject matter, but also evidences the more interesting and profound aspects of bold, selective statements, in contrast to the obscure and minimal; there are the declarations of dominance and focused attention in opposition to the supportive elements . . . and what do we now find? That the orchestration of drawing is woven into patterns and design, for, as we make decisions that affect the drawn subject, we are also making decisions that relate to volume, form, and space: in a word, then, composition.

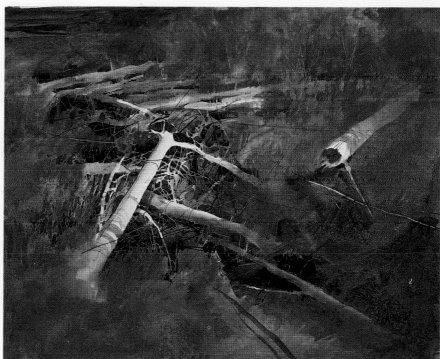

I was recently asked by one of my students if I ever painted abstractions. Immediately, I knew I must help that student to see that when we artists manipulate line, dimension, pattern, balance, and other matters that are not immediately discernible "things," we *are* abstractionists. The various "isms" have become a haven for those who are comfortable only when they can put neat, but completely irrational, labels on an artist's efforts. The fact that a painting displays familiar content is of less significant an impact than the totality of its composition, which *becomes* the painting.

To illustrate additionally the interwoven reliances of drawing and com-

position, I will plan my painting by way of an initial response and exploration that might be described as the preliminary sketch. Perhaps that is what it is to many—a first step or an outline for the painting. However, to me, this value study (always in black and white) is the first breath of life for the painting that evolves. It is in these value studies that I sense shape, movement, atmosphere, and dimension. (I wish I could remember who it was that said that the painting is always there, waiting for the artist to explore the surface and release it!) Value studies are, for me, vitally important, for they provide the opportunity to plan large statements. They are

not miniaturized displays of delineated objects. Look again at the value studies in this article. They are not refined arrangements of subject matter. They are even, at first glance, rough to the point of seeming crude. However, each is the heart of the painting to be, for each promises the substance of composition and pattern.

If the creating of the black-and-white value patterns presents the structure of design, balance, emphasis, movement, and other ingredients that add up to being the foundation of the painting, then where does color enter the scene? Color is the flavor that enhances the emotional qualities of painting. To the black-and-white chords that might represent the primary elements of form and pattern can be added color, which can bring about resonance and harmony. Color can be used in whatever fashion that we feel will elicit the intended responses from our viewers. I am convinced that if color is a problem area for some painters, it is not so much due to a lack of knowledge or sensitivity, but, rather, a reluctance—even, perhaps a fear—to approach color with an attitude of adventure. Lord knows, we can be intimidated easily enough by countless little jabs of self-consciousness until we recognize the futility of timidity.

Color can convey mood, atmosphere, perspective, accented (or muted) interests, harmony—or *dis*harmony, if that is the artist's wish. Assuredly, though, color will do nothing for those who are so faint of heart that they do not explore. It's fascinating to discover that, as the artist becomes vigorous in his or her approach to color, he or she becomes comfortably disposed toward strengthening other facets and attitudes toward painting. I would like to say here that I am not encouraging a hurdling, no-holds-barred approach to painting, color declarations included. Thoughtful determination must accompany bold, energetic attitudes in order to avoid the otherwise resulting bombardment of accidents. The qualities of painting cannot be arrived at through groping, stumbling, and crossed fingers, any more than an elegantly beautiful musical selection can be composed with an indiscriminate arrangement of notes.

Fairly often, a student will tell me that he or she "can't find anything to paint." Now, there's no question that the artist will be stirred, and even excited, by the exploration of unfamiliar territories. Just the act of visiting new places enables us to see the character and "paintability" of what we find in these excursions, whether they are in

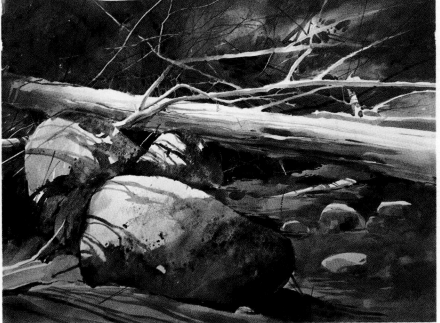

the next county or far beyond. Yet, by not permitting ourselves to see the possibilities of what might be within the eye's range at almost any moment, I feel that we diminish our range of responses. We must allow ourselves to be receptive to subject matter. More accurately, we must be responsive to designs, shadings, light patterns, textures, contours—all of which, and more, can have little to do with the objects that might be sought as the elements of a "picture." It isn't, after all, the subject matter that promises our painting results; rather, it is the manner in which we permit ourselves to see and interpret what is laid before the eye. Whether any subject becomes exquisite or dreadful is not within the power of the subject to determine, but within our own ability to envision, to

translate, and to realize that there are limitless stories to be told about any subject. The spirit of what we offer in our painting lies with *us* and not within the forms that are presented to us. What better illustration is there than to remember that Claude Monet created his garden and *then* spent the next half-century searching, experiencing revelations, and finding moments of enchantment there that led to the mesmerizing beauty of his works.

Nature presents us with all kinds of content and flavors, but if any of her material becomes spiritless or ordinary in an artwork, it will be due to the flaws within the painter who has refused to let his or her thinking *fly*. Let us always be, as a child, innocent enough to view with awe the textures

of an open field, the rhythmic movements of quiet ponds, the dynamics of ageless rock, and the beckoning of all that is life's—and nature's—panorama. Also, let us always be curious, energetic, and demanding enough to accept what nature offers us—but in the light of how we, as painters, will translate her shapes and mysteries.

Finally, of course, we come face to face with the moment of decision regarding how we intend to apply our painting methods to narrate best the visual message. Is the quality of atmosphere to be accentuated, or are there to be highly keyed subtleties? Are, perhaps, the vigor and play of dashing movements to be dramatized? These are the kinds of thoughts and painting plans that determine the selection of the texture of paper, the palette of color, the tempo of treatment, and every added note that will contribute to the evolvement of the painting's personality and character. Just as the sculptor molds and coaxes the clay to take form and dimension, the painter manipulates the two-dimensional imagery and illusion to create a painting.

My palette includes Winsor Blue, French ultramarine, cobalt blue, cobalt turquoise, Winsor Green, olive green, Winsor Red, cadmium red light, cadmium orange, cobalt violet, Winsor Yellow, yellow ochre, raw umber, burnt umber, and burnt sienna. Although I might envision a certain range or feeling of color will be expressed within a painting, I always have the full palette of color available in order to avail myself of whatever might be added to the dominant color of the moment—influence or harmony. One of the teaching methods that I feel to be invaluable to my students lies in periodic painting demonstrations. In turn, one of the first demonstrations I present to my students is the portrayal of large masses of green tree foliage, green fields, and green shrubbery—without once using either of the greens that I've mentioned as being in the palette—not to imply, certainly, that using the Winsor Green or olive green is illegal, but, rather, to illustrate the exciting prospects of all kinds of color—greens included—that can be arrived at by exploring the palette and allowing the pigments that are waiting there to prove their potential to create live, forceful, and stirring watercolors. I feel, too, that color is at its most profound and evocative state when it is reduced from its pure form; use pure color, with some discretion, to provide a bit of spice or to lend a dash of "surprise" to the eye.

Continuing to describe the essential tools, I can't overlook brushes. With

Opposite page, above: Value study for *A Sheltered Place.* Opposite page, center: *A Sheltered Place,* 1982, watercolor, 24 x 32. Private collection. "High in the mountains," says Shapiro, "I found this collection of eccentric forms—some weighty and unmoving, while others were spidery and fragile. These contrasts of character seemed so right for the fascinating variety of color and shadings of light."

Top: Value study for *Longer Days Coming.* Above: *Longer Days Coming,* 1981, watercolor, 20 x 30. Courtesy Gallery of the Ravens, Estes Park, Colorado. For this work, Shapiro chose a rough paper surface (d'Arches 300-lb.), because the texture encouraged the pooling and settling of liquid color. "This, I felt, would enhance the development of the intended feelings of space and the control of some of the softer edges," says the artist. Only the area of the sky was initially wet; into this, cobalt blue, cobalt violet, and raw umber were introduced and applied with sweeping brushstrokes. The other large areas were painted while the paper was dry.

some envy, we can remember that van Gogh, while on one of his sketching excursions in the French countryside, found that he had left his brushes back in his studio and proceeded to pluck a small branch from a nearby tree and chew the end of it until it was supple; he then went about painting one of his masterful studies. Most of us, however, must rely on such names of brush manufacturers as Winsor & Newton, Grumbacher, Simmons, Delta, Strathmore, and others who produce fine brushes. Although I find myself magnetically drawn to the brush cases in the art supply shops and I have gathered dozens for my studio, I do all of my painting with Nos. 4, 8, and 10 round red sables, plus a one-inch-wide flat ox hair, fine grade.

In my studio, I keep a wide variety of papers on hand, from the very smooth (hot pressed) to the extremely rough (a handmade paper imported from Italy). The names include d'Arches, Crescent, RWS, Saunders, Fabriano, and others. My papers are either 300-lb. weights or lighter weights that have been bonded to heavy rag boards and marketed as watercolor boards. I select the paper texture that will wed itself to the intended spirit of the painting.

After selecting the paper, the first step is to give the paper a gentle, but thorough, sponging with cold water. This is done so that some of the sizing is removed, thereby making the paper more responsive to wash and brush handlings. This sponged paper is allowed to dry, and an HB or 2B pencil is then used to sketch lightly the major areas of the painting. I feel that, if the pencil drawing becomes too studied or delineated, the painter might be lured into sterile renderings of the shapes that will have been so carefully and fully penciled. As has been mentioned, drawing is a *total* term, and a great deal of my drawing is done with the brush. This can be a more comfortable concept when it's realized that we can define drawing as being not only a statement of line (made with the pencil), but also a statement establishing mass and volume (made with the brush). The amount of pencil drawing should be only as much as can be determined by the painter as being necessary for that particular painting. As an example, a subject in which there is a great deal of architectural form or ornamentation would, understandably, require a more studied pencil statement than would a strongly patterned interpretation of natural forms.

All the while, of course, the value study is close at hand, created from

on-location observations and/or from photographs taken to record information. In any case, and as I will repeatedly emphasize, the painter's role is not to duplicate or literalize the subject, but to allow the romance of interpretation, invention, and aesthetic judgments to play its part in the creation of the painted essay.

Just as the texture of the paper is selected for the way in which it will contribute its character, other thoughts and decisions are put together as the painting plan evolves. Among the more incisive statements, remember, will be the indications that exist within the preliminary value sketch. However, the watercolorist is called upon to be a virtuoso in his or her han-

dling of the medium. He or she must decide, for example, whether the painting is to be massively wet or delicately restrained. A decision must also be made as to whether there is to be a predominant flavor of immediacy of handling or, possibly, the almost iridescent quality of overlaid glazes. I resist, though, the pigeonholing of techniques and usually find that my paintings are a combination of many handlings orchestrated to provide me with what will bring about an intended result.

However—and this is a *big* however—whether one painting technique or another is planned, there is the overriding importance of establishing the larger, blocked-in elements of the

painting's design—and doing so as soon as possible. This doesn't mean that caution or control is tossed out the window, but, rather, that there is to be an attentive eye, first, to cohesion, rhythm, volume, and other broad compositional importances. Tons upon tons of watercolors have been prevented from becoming creditable efforts as the result of an almost obsessive drive toward prematurely stated, tedious detail. The seasoning of refinement and delineation, once the larger patterns have been established, is one thing. The fondling of tiresome, small descriptions, however, can be disastrous without first presenting the overall substance and structure.

In the act of painting, I usually keep my paper inclined at a slight angle, while laying in the large passages of color and value. If I have intended for there to be a massive flow and interplay of pigment, I first wet the paper with either a soft sponge or a two-inch-wide brush. If, instead, the paper is to be dry, the handling of the brush will be no less sweeping and the brush will be no less loaded with wet color, but the evidence of brush movement and selective placement will play a larger role. In the meantime, any areas that are planned to remain white will either be painted around, or protected with one of the liquid friskets that are on the market for this purpose. While the washes remain wet, I continue to model, manipulate, and otherwise influence or affect the illusions and images. While the areas are wet, they are agreeable to added handling. If the areas are only moist, though, it is best to wait until they are completely dry, at which time additional washes or "commentaries" can be introduced to develop the desired result for that part of the painting. The last statements made are the accents, the details, the flourishes, and whatever else is to be introduced as the final, parting embellishment. It's as though, with a flick of the wrist, we pat into place that loose strand of hair, move into the center spotlight, and present our talents, such as they are, to the world. ●

*Irving Shapiro was born in Chicago. His earliest years were greatly influenced by the works of Edward Hopper, Georgia O'Keeffe, and the watercolors of John Singer Sargent. After graduating from the American Academy of Art in Chicago, where he is now the president and director, as well as an instructor of watercolor painting, he established his career in advertising layout and illustration. He became a member of the American*

*Watercolor Society (AWS) in 1957. The National Academy of Design presented him with the Ranger Award for his watercolor that appeared in that year's AWS exhibit. He has since received many awards, the most recent being the Mary S. Litt Medal in the 1981 annual AWS exhibit.*

*His paintings are in many private, corporate, and museum collections, and he is represented here by the Everett Oehlschlaeger Galleries of Chicago, Illinois; the Gallery of the Ravens in Estes Park, Colorado; and the Munson Galleries in Santa Fe, New Mexico.*

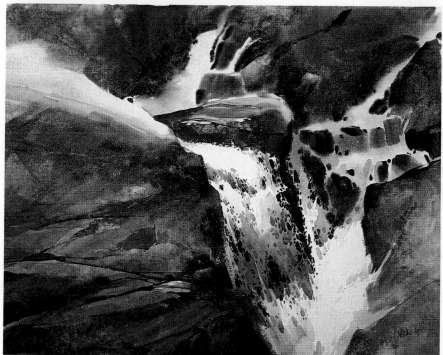

Top: Value study for *Rushing Free.* Above: *Rushing Free*, 1981, watercolor, 24 x 32. Courtesy Gallery of the Ravens, Estes Park, Colorado. "In Colorado, I was struck by the movements and patterns of the wildly varying values found in this scene—some were dazzlingly light, while others were half-lit in their secretive recesses," says Shapiro.

Opposite page, above: Value study for *Fisherman's Wharf.* Opposite page, center: *Fisherman's Wharf*, 1981, watercolor, 25 x 33. Collection the artist. "In this work, I knew there was a network of areas that should not be painted as individual sections: that would fragment the composition with disassociated elements. The design of the darks and lights and the dash of brushwork—these were the primary objectives," comments Shapiro.

# USING DIAGONAL COMPOSITIONS IN WATERCOLOR

BY CARLTON PLUMMER

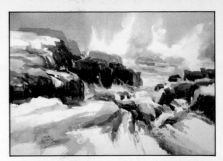

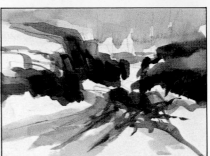

1. *Ice Floe*, 1978, watercolor, 22 x 28. Collection Mr. and Mrs. Richard May.

2. *Winter Storm*, 1980, watercolor, 22 x 28. Collection Mr. and Mrs. William Gruener.

*Carlton Plummer, a former illustrator and art coordinator, is currently a full-time professor of art at Lowell University in Lowell, Massachusetts. Born and raised in Maine, he attended Vesper George School of Art, Massachusetts College of Art, and Boston University (MFA).*

*Plummer is an active member of many organizations, including the American Watercolor Society, Allied Artists of America, and New England Watercolor Society. He has traveled extensively in Alaska, Europe, the Far East, the West Indies, and North America.*

*Winner of over 40 national awards from major shows, he is represented by galleries in six states. His articles and artwork have previously appeared in Palette Talk and Ford Times magazines.*

*Plummer conducts painting demonstrations, critiques, and workshops throughout the East, including his popular Maine coast workshop in Boothbay. He maintains a studio/gallery with his wife, Joan, at their summer home in Boothbay and their winter home in Chelmsford, Massachusetts.*

SEVERAL YEARS AGO, after much mind searching, groping for what could be called a glib statement to sum up the purpose of my painting, I became aware of an obvious diagonal structure throughout the majority of my work. After a more scrutinizing look, it was apparent that this diagonal was a major way of emphasizing drama and emotion in my watercolors.

I used the diagonal intuitively to achieve space and depth, while seemingly unaware of the obvious dramatic impact. It is curious to see how the obvious can sometimes be overlooked. Now the use of diagonals—whether in line, tone, color, or texture—is an integral part of my intellectual and creative process.

Although it may not always seem obvious, this aspect of design exists within the landscape structure, waiting for us to extract it through a process of decision making, until we can then translate it into a well-designed visual expression. The intent of this article is to demonstrate how the diagonal can be utilized as a major force in visual dramatization and expression of emotional feelings about our environment.

Looking back on my more successful lessons given in workshops or in the classroom, I am reminded of the numerous times I have stressed the use of the diagonal in composing paintings. It would seem a natural direction in which to proceed, but one that was in need of a little help from

me. Therefore, with this in mind, I would like to share this knowledge and experience based on years of looking, thinking, and painting in the hope that you will draw upon it for future reference.

Perhaps it would be appropriate now to introduce my favorite subject matter for painting, the *Maine Coast*. More specifically, I find the Boothbay area to be most stimulating. It is this area, with its rugged, rockbound coastline, that provides continual inspiration and supplies an endless array of subject matter, whether panoramic or detailed. Although we have traveled extensively, my wife and I return to the alluring beauty of Maine to be stimulated anew by her inlets and rock masses.

I have selected some of my watercolors to accompany this article in order to illustrate the use of the diagonal. All four paintings are shown above their preliminary value studies, which show the accentuated angles and tones. Although the subject matter is obviously coastal, I have included a variety of situations and elements to show how the diagonal is effectively used to move the eye around the composition and to strengthen the statement made on the painted surface.

The design possibilities when using the diagonal are vast and will add strength to your work. The basic oblique line when used in conjunction with another converging at a point somewhere on the horizon line is one way of showing perspective. A series

of short horizontal lines getting closer together between the two oblique lines denotes perspective or space.

Diagonals can be used in a more complex and not-so-obvious manner, such as in the painting *Ice Floe* (No. 1). Here, a zigzag of diagonals formed by ice cakes and open water gives us a feeling of moving back into space. This aerial perspective, enhanced by the constriction of shapes, results in an illusion of light, reflection, and atmosphere. The crate frozen into the foreground ice is on an angle, thus forming a diagonal that leads the eye into the picture. The white of the paper is left in a variety of ways to create the illusion of light and reflections bouncing around the scene.

The rock and snow masses in the painting *Winter Storm* (No. 2) illustrate the force with which converging shapes and lines move the viewer's eye into the impact area. The vertical action of the surf stops the receding action of the diagonals. You sense the presence of churning water beyond the rock mass, but are caught up in the energy of the dark rocks. Once again, the lines come high off the paper and from the foreground to give you the feeling of being in the immediate area. This convergence of mass and line is further emphasized by the dark edges of the rock against the snow and ice.

In *Lowtide Lobster Boat* (No. 3), there is a combination of conflicting or opposing diagonals from various angles. The tilting of the boat into the diagonal of the wharf and building, as well as the strong slant of the foreground log against the diagonals of the wet reflections, results in an interplay of active directional movement. The angle of the roof on the fish house

moves the eye downward to the boat. It is this directional movement that entertains the eye through diversity and creates the illusion of space.

Converging diagonals in *Boat Adrift* (No. 4) form a wedge in which the runaway skiff angles dramatically. The eye then "completes" the inevitable collision of the boat against the rocks. The foreground rock mass leads our eye up and over a variety of pinnacles to the impact area. This work illustrates the use of a strong diagonal statement in the foreground contrasting against the lighter middle ground to create a sense of depth.

The artist is much like the actor on a stage, constantly striving to gain the full attention of the audience while continuing to develop the mood of the situation. This challenge can be met in a variety of ways, involving a vast range of techniques and philosophies—the key word here being *variety*, or *diversity*, within the design structure. Therefore, by this visual entertainment, we hopefully trigger the emotions and intellect of the viewer. If this is true, then the artist has been successful in communicating with his or her audience.

Although this article has focused on one concept, that of the diagonal, I would be remiss if I did not mention that, as a painter, I consider myself a colorist in the strictest sense of the word, one who has been strongly influenced by the watercolors of John Singer Sargent. I enjoy exploring the emotional use of color to express light, reflection, and the special excitement that I strongly feel about my visual environment.

Being a colorist, immersed in emotional or subjective use of color, as

well as being concerned with naturalistic effects found in aerial perspective, I feel the need more for pure colors than neutrals and browns. It is the overlapping and selective juxtaposition of these colors that provide me with the effects of sunlight and shadow. The darks are made with dark colors, not black.

My palette includes: ultramarine blue, cerulean blue, cobalt blue, Prussian blue, alizarin crimson, Permanent Rose, cadmium red light, cadmium orange, cadmium yellow pale, cadmium lemon yellow, new gamboge, sap green, burnt sienna, and raw sienna.

Because I demand so much from my brushes, I insist on excellence of quality and continue to search for new brushes on the market. Presently, I use Winsor & Newton, Percy P. Baker, and Robert Simmons. My brushes vary from expensive red sable rounds—Nos. 5, 8, and 12—to less-expensive ½″ and 1″ Aquarelles. I also include a 1¾″ sable wash brush and a Robert Simmons white sable Goliath to facilitate covering large areas.

My choice of paper varies according to my mood and subject matter. I find 300-lb. Fabriano cold-pressed most satisfying, but, on occasion, use T.H. Saunders, Watchung, and Aquarius in 140-lb. weight. For smooth surfaces, I like four- or five-ply Strathmore Bristol or illustration board. Because of its brilliant white, I prefer 100 percent cotton 140-lb. Fabriano for doing watercolor portraits.

Homosote, a lightweight gray fiberboard bought in building supply centers, serves as a base for my paper. I staple the paper only at the top and use thumbtacks for the remainder, allowing for expansion of the paper.

I paint kneeling on a pad, facing the sun so as to keep the board shaded as much as possible. Sometimes I stand with the board tilted slightly on a rock, depending on the location. I use a John Pike Palette, using the lid for an extra mixing area. Most of these items, including my camera, sketchpad, sunglasses, and lunch are placed in a tote bag or small day pack. This allows me the freedom needed for a variety of locations. Sometimes that location finds me 10,000 feet above sea level on a snow-covered mountain in Alaska or in the jungle in Thailand at 108°.

In conclusion, remember that the diagonal plays a major role in forcefully accentuating action, movement, direction, rhythm, perspective, space, and emotion when involved with visual interpretations of the world around you. When in doubt, place it on an angle! ●

3. *Lowtide Lobster Boat*, 1980, watercolor, 22 x 28. Collection Mr. and Mrs. Thouret.

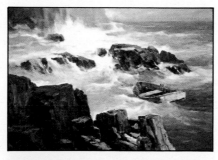

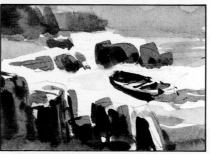

4. *Boat Adrift*, 1980, watercolor, 22 x 28. Collection Mr. and Mrs. Gary Evans.

# PAINTING ON LOCATION WITH WATERCOLOR

BY ALAN SINGER

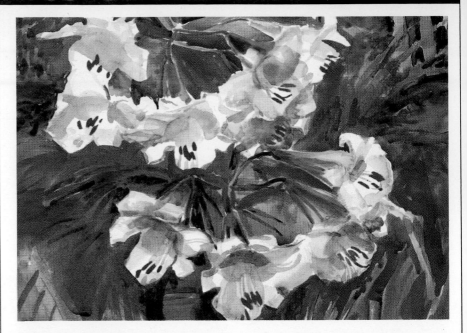

*Alan Singer began formal art training at the Art Students League and went on to earn a BFA degree in painting at the Cooper Union School of Art & Architecture in New York City. He received a master's degree in fine art from Cornell University and, in 1975, his illustrations for* The Total Book of House Plants *were published by Delacorte Press.*

*Singer's paintings have been shown in many solo and group exhibitions, and he participated in the American Watercolor Invitational held in the fall of 1983 at the Hummingbird Art Gallery in Tucson, Arizona. His works are in public and private collections. He has been the recipient of awards from the Skowhegan School of Painting & Sculpture, Yale University, and the National Arts Club. The Postal Commemorative Society gave the artist and his father, Arthur Singer, the "Best of the Year" award for the 1982 stamp designs depicting the birds and flowers of the 50 states.*

*Alan Singer is a member of the Graphic Artists Guild and resides in Brooklyn, New York.*

SOME OF THE BEST moments I have spent as a painter have been outdoors with my watercolors, at some distant locale, away from my New York City studio. Especially suited to my temperament, the watercolor medium can convey a certain light or mood and perhaps suggest the complexities and rhythms in nature. A watercolor is my intuitive response to observed reality.

A fellow artist once remarked to me that "when making a watercolor, one has to be like a tightrope walker dancing across the paper" in a state of excited equilibrium. Years of experience have revealed the truth of this observation, but there is more: the execution of the work, be it spontaneous or deliberate, must be structured in a logical way as the work progresses from start to finish. To do this, one must understand the medium thoroughly, and this comes at the expense of much trial and error and experimentation.

My first exposure to watercolor came from the work of my father, Arthur Singer. He is a well-known naturalist and a gifted watercolorist. He would take his paints with him on family vacations, and I would watch him work as he patiently recreated the scenes in front of us.

As a young artist, I drew my initial inspiration from my father's work and I also drew comparisons between the qualities in his paintings and those of Corot and, more recently, in the work of Edward Hopper. Naturally, following my father's example, I tried my hand at watercolor, but unaccustomed to the rigors of the medium, I soon floundered and abandoned it for a time as a means of expression.

We develop a knowledge of our limitations within each given mode of self-expression and, as with other life experiences, we work to make the best of our abilities. We measure what we have done against what we think we can accomplish or what we desire as a final result.

As a teenager in high school, I continued to paint in oils and then acrylics and later, after entering college at the Cooper Union School of Art & Architecture, my interests in watercolor began to surface again. At the time, Cooper Union maintained a 1,000-acre campus away from the main buildings in New York City. I would ride the bus out of the city to Green Camp, as it was called, in the hills of New Jersey. During these frequent commutes, I would read the verse of the American Imagist poets, notably William Carlos Williams who lived and worked in New Jersey and Wallace Stevens who was from Connecticut. Their words came as an enlightenment to me, for in their work they summoned up the landscape and its inhabitants with a simple grace and a powerful identity.

The reading I did during that time actually sharpened my eyes and my art. I began to have a better knowledge of what I was looking for in my own work. My reawakened excitement came from painting direct from the motif outdoors as I matched my skills with the incredible events in the natural landscape. Teachers such as Paul Resika, Leland Bell, Wolf Kahn, Nick Marsicano, and Lucio Pozzi were supportive, and I was propelled along by new discoveries in the field, as well as by a greater knowledge of the theo-

Opposite page: *Regal Lilies,*
1980, watercolor, 14½ x 17½.
Collection the artist. The delicate
tones give the form a vivaciousness.

Above: *The Great Palm (Trinidad, West Indies),*
1980, watercolor, 24 x 18. Collection the artist.
This work was painted between cloudbursts
in a tropical rainforest.

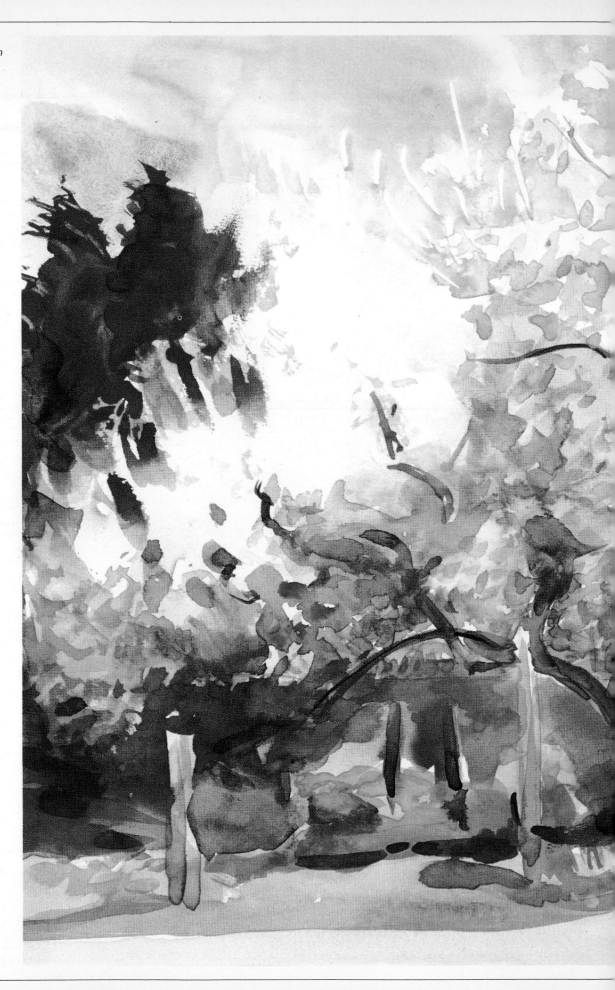

*Spring on Hambletonian Road,* 1980, watercolor, 15 x 18. Collection the artist. This subject inspired a distinctive brushstroke.

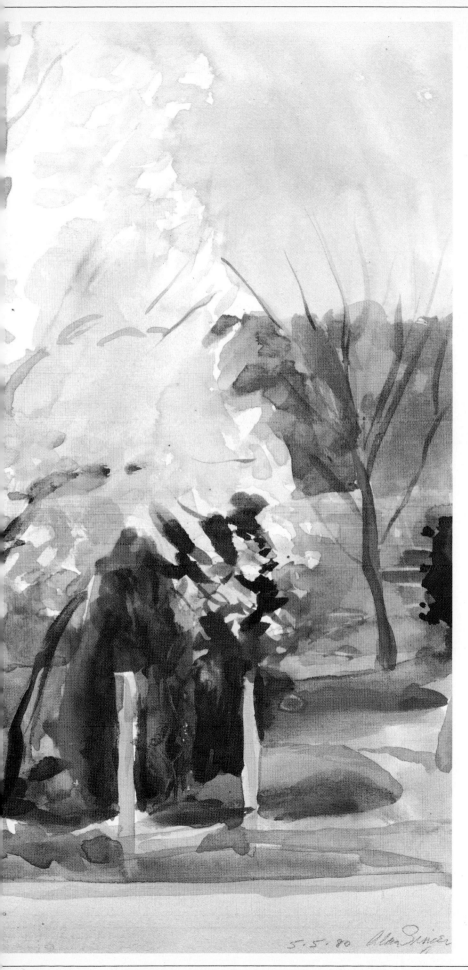

5.5.80 Alan Spencer

ry and history of painting in general.

My interests in art are joined with my love for the natural landscape. I left New York City to attend graduate school at Cornell University in the midst of the spectacular Finger Lakes region of New York State. There, I listened intently to my teachers as they spoke of developing color and spatial relationships in painting, and I worked ambitiously to put these lessons to good use.

Outdoors, I felt I was a good judge of the spirit and sense of place I happened to be in. Part of the painter's paradox is to have intense feelings about your subject while still maintaining an objective eye on what is in front of you.

I have said that there should be a structure or a plan in mind as one begins to work. Watercolor, by nature, is a fast medium with which to work, so by concentrating on the *process* of the work, I can help keep my eye, hand, and mind on the essential aspects of the painting in progress. I want to keep the transparent quality of the paint which, I feel, is the key to the life of a watercolor. To avoid over-working a painting with too many washes or layers of color, I plan in my mind what should be established first, and then next, and so on.

My paintings begin with light pencil notations that build a kind of architecture of space. I lightly sketch the contours of the large masses and note strong vertical and horizontal divisions. I rarely spend time making detailed drawings before I paint, as I would rather channel my energies through the brush itself.

It is important for me to set to work at once, while still absorbed by the *challenge* of what is to come. Quickly, I adjust my position so that my paper is tilted at a comfortable angle and the rest of my materials are easily accessible. Frequently, I work with my back to the sun so there might be a shadow cast on the work in progress.

Taking into account my ambitions for the day, I pick up my brush. Fortunately, for me, most of the paper I use is not prohibitively expensive; thus, a false start, or one that falters in the first few minutes, is simply tossed away. I never labor over a work if I feel I have lost my concentration. The work is established with light touches of color followed by the middle and darker tones. The early stages of my work are more linear, while the later stages incorporate flat washes of color and an assortment of marks as called for.

Constantly referring to the scene in front of me, I observe the relationships of the forms in reality, and then adjust those on the paper. I want the sense of

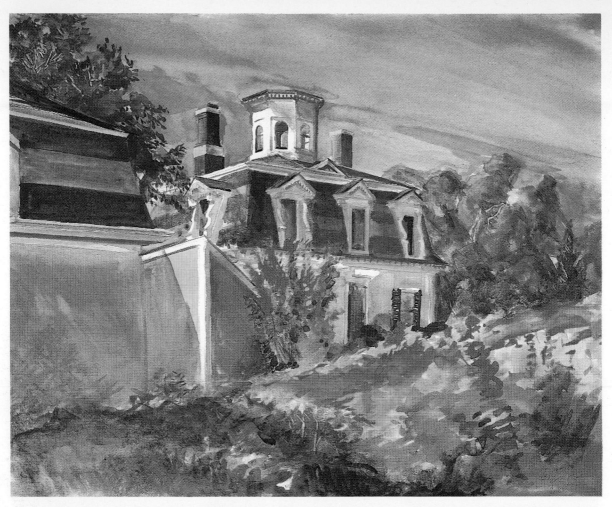

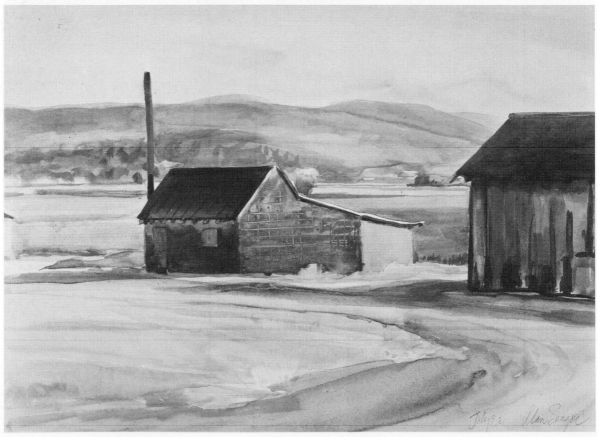

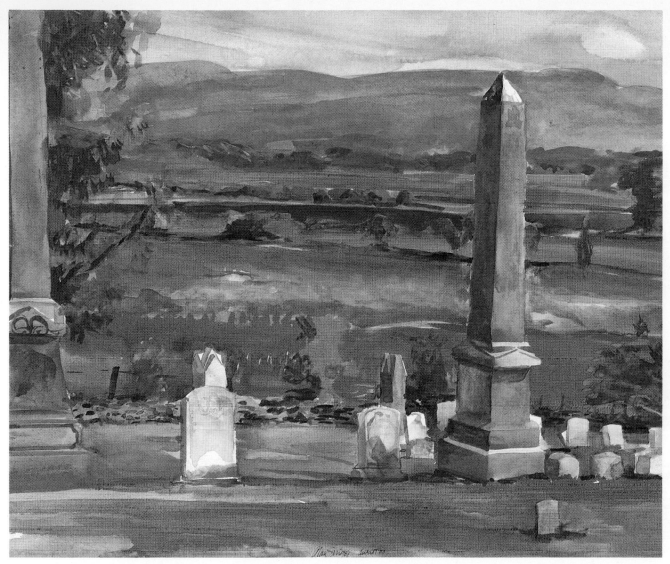

Above: *Obelisks at Logee Cemetery,*
1983, watercolor, 15 x 18. Collection the
artist. Photo by Dorothy Zeidman. I ad-
mire the stoneworker's art. I think that the
mingling of personal and natural history
make this a powerful motif.

Opposite page, above: *Captain Penni-
man's House, Eastham,* 1983, watercolor,
15 x 18. Collection the artist. Photo by
Dorothy Zeidman. On a brilliant day on
Cape Cod, I was attracted to and chal-
lenged by this fascinating house.

Opposite page, below: *Farmworkers'
Buildings (Pine Island, New Jersey),* 1981,
watercolor, 15 x 18. Collection the artist.
In this scene, I tried to capture the sad
poetry of the lives of migrant workers.

air, the flowing of water, the anima-
tion and vivaciousness of nature to
permeate my art.

I have become very selective about
my choice of materials and how I use
them. I tend to keep my colors
unmixed, and I shy away from grayed
colors unless I have a specific need for
them. Experience has taught me that
watercolor dries lighter and appears
grayer, so I tend to exaggerate my
color relationships. I rarely use a wet-
into-wet technique that some artists
prefer, because I feel it would destroy
the color relationships which are the
building blocks of my work.

Over the years, I have been very
careful when choosing colors for my
palette. First, let me say that I actually
prepare two palettes, one for warm
tones (the browns, reds, and yellows)
and the other for cool tones (blues,
greens, and violet). In the past, I have
produced a chart for myself that com-
pares the paints straight from the tube
as well as paint thinned to a wash. I
make color comparisons between the
same color made by different manu-

facturers to determine which colors
are most suitable in their brilliance
and tone. When they are available, I
work with Old Holland watercolors or
Winsor & Newton, and I prefer the
hot-pressed surfaces of Fabriano,
d'Arches, and Whatman papers.

Other Masters have set the standard
for work in this medium. I cannot
think it possible to have come this far
without lessons learned by looking at
actual work by Cézanne, van Gogh,
and Delacroix; or the Oriental artists
Wen Zhengming and Ogata Korin; or
the Americans Winslow Homer and
Edward Hopper. Many abstract paint-
ers, such as Kandinsky, have influ-
enced my sense of pictorial organiza-
tion.

In this, as in any other, medium, we
must let ourselves have the freedom to
find and use our own poetic vision.
From great art we can obtain a sense
of the creator's joy in creating and,
also at that same moment, a sense of
the transient part we play in the ongo-
ing stream of events. •

# GORDON WETMORE PAINTS A WATERCOLOR PORTRAIT

## BY BARBARA WHIPPLE

2

3

4

5

1

*Barbara Whipple is a contributing editor of American Artist. She holds an MFA from Temple University. A printmaker, she exhibits regularly and gives workshops and critiques in the Southwest.*

GORDON WETMORE doesn't always do portraits in watercolor, but he has found that the medium—with its characteristic freshness, vitality, and informality—seems to be gaining in popularity among his clientele.

Watercolor dries lightly and can thereby give a washed-out appearance. To overcome this drawback, Wetmore uses plenty of pigment and allows the paint to dry between applications if he needs to build up layers of color. He finds watercolor especially well-suited to the rendering of detail, and he doesn't hesitate to use opaque colors if needed.

Wetmore began using watercolor in earnest while working on the best-selling book *Promised Land* (1978), a book about Israel, with text by Leon Uris and Abba Eban. Wetmore spent a year doing the paintings for the book and shuttled around a lot in the process. As so many traveling artists before him have found, watercolor is highly portable. Also, it reproduces well. Because this book was so suc-

cessful, Wetmore decided to do another similar book about Ireland.

This time, instead of dashing back and forth, Wetmore took his family, and they lived in a picturesque cottage in rural Ireland for four months. He took 2,000 slides and made hundreds of sketches. Life in Tipperary had a fragile quality about it, and the tranquil way of life affected him profoundly. The result of this trip, and the eight months of concentrated work that followed, was the book *Ireland, Portrayed by Gordon Wetmore* (1980), which has a foreword written by the late Princess Grace of Monaco.

Wetmore got his first big break in 1971, when he was commissioned by the state of Tennessee to do a portrait of President Nixon. Before this, he had earned his degree in art at the University of Tennessee and had taught for a time. But he found teaching so time-consuming that he had little time for his own painting. Finally, he stopped teaching in order to devote himself to his own work. Now he does the kind of teaching he most

6

enjoys—teaching portraiture to other professionals. He's a member of the National Advisory Board of the Portrait Club of New York and teaches annually at the National Portrait Seminar, an important annual event for portrait artists.

A friendly, open person, Gordon Wetmore seems uniquely suited to portrait painting. When doing a portrait, he has a long first session with his sitters, taking lots of pictures, making sketches, chatting, and getting ideas from them about the kind of poses they might like. A warm and lovely painting of a mother reading to her children in bed resulted from the suggestion of the sitter.

Wetmore next makes a preliminary study, which he submits to the sitter for approval before beginning work on the actual painting. The second and final sitting is done just before the portrait is completed. All of this takes about six weeks.

The artist thinks of the face as a series of bands, composed of four colors: yellow, purple, red, and green. The first band crosses the forehead, where the skin is closest to the skull, and is primarily of yellow ochre tones. The second band is across the eyes, where the skin is thin, and it's done with a lavender tint to make the eye sockets and the indentation above the nose seem to recede. The third band is composed of warmer tones, for the nose, cheeks, and the ears. The nose is reddest, because the light slides off it and hits the cheeks broadside, lighting them up more. An ear in shadow is a

deep red, and a very light pink is used for the ear on the lighted side.

The "mouth barrel" is a green tint, which makes the area around the lips and chin recede properly. The neck and other shadowed areas also have a greenish tone. The chin gets a dash of the warm color used in cheeks and nose to help make it come forward.

Wetmore's basic flesh color mixture is cadmium red light, yellow ochre, a touch of cerulean blue, and plenty of water, mixed in various combinations. His watercolor portraiture generally is done in four stages, working from light to dark.

7

## DEMONSTRATION

**Step 1.** He begins the portrait of his daughter, Amy, by first sketching her likeness in pencil on stretched d'Arches 140-lb. cold-pressed paper. Using a No. 11 sable, he models the upper "band" of the forehead in a warm ochre tone, leaving some untouched white paper for the highlight.

**Step 2.** Deepening the ochre a bit with cadmium red light and cerulean blue, Wetmore models the eye socket, blending it with the previous passage using a No. 11 round sable. He prefers to deepen the blue shadow while the

undertone is still wet. The iris is painted, using the basic flesh tone with more cerulean blue and a No. 8 round sable.

**Step 3.** Wetmore develops the third "band," using rosy hues made by adding more cadmium red to the basic mixture. Note that the ear on the shadowed side is a deeper tone and that a dash of red has been applied to the chin area. Additional definition has been made to the bridge of the nose, using a No. 11 round sable.

**Step 4.** Wetmore washes in a greenish tint for the fourth "band," which indicates the receding areas around the mouth and under the chin, using more cerulean blue in the basic mixture and a No. 11 round sable.

**Step 5.** The neck area is painted with a greenish color, which can be "warmed" when dry if needed. Using variations of his basic color mixture and a No. 11 round sable, he models in shadows at the eye corners and under the nose, lip, and chin.

**Step 6.** Wetmore uses burnt sienna mixed with yellow ochre and cerulean blue for the light parts of the hair, and burnt sienna and ultramarine blue for the dark areas. He uses a No. 1 flat sable brush for the larger areas and a No. 4 round sable for smaller strands. White paper is saved for highlights.

**Step 7.** Wetmore washes in the background with clear water, using a 1½" flat sable, and then adds a mixture of the three basic colors—yellow ochre, very little cadmium red light, and cerulean blue, grayed with a touch of black, applied very loosely.

With all the areas blocked in, Wetmore now begins with the final details. Using a No. 6 round sable, he models the whites of the eyes, using the basic flesh mixture plus enough cerulean blue to make a pleasing gray. When the paint is dry, he paints the irises with a solid color of mostly cerulean blue, outlined with a darker value of the same color, which is also applied along the top where the lids shade the irises. He uses a dot of black for each pupil and makes the secondary highlight by moistening the area and lifting the paint off.

He models the folds of the lids with a mixture of burnt sienna, ultramarine blue, and alizarin crimson, using a No. 4 round sable brush. The lower lids are painted with a mixture of burnt sienna and cadmium red light, and when dry, the eyelashes are touched in, using burnt umber and black. He dots the corners of the eyes with cadmium red light, leaving an untouched spot of paper for the highlight.

The eyebrows have already been suggested by the shadow tones, and Wetmore begins painting them darkest near the nose, then the middle value at the end, and the lightest in the middle, using a No. 6 round sable and a combination of burnt sienna, cerulean blue, and yellow ochre. Finally, with a No. 0 sable, he flicks in the suggestion of eyebrow hairs and a few strands of hair at the perimeter of the head.

A mixture of alizarin crimson, burnt sienna, cadmium red light, and cerulean blue is used to paint the mouth, and more water is added to the mixture for the lower lip. He paints the nostrils with a mixture of burnt umber, alizarin crimson, and black for the shadowed side, and burnt sienna, cadmium red light, and a touch of black for the lighter. These same darks are used for the line between the lips and the lines at the corners of the mouth. Finally, Wetmore adjusts all the shadowed areas so that they work together satisfactorily. The completed work: *Portrait of Amy*, 1982, watercolor, 18 x 14. Collection Mrs. Gordon Wetmore.

Wetmore painted *Portrait of Amy* in his studio, the remodeled attic of his Signal Mountain, Tennessee, home. It's a space as open and congenial as the artist himself. There's room for his wife's piano, and two wooden swings hang from the rafters for the pleasure of his two daughters. The artist's warmth and friendliness are further expressed by what he says about doing a portrait: "I never consciously alter features, but I think there's plenty of latitude to accent the positive elements." ●

# STEPHEN QUILLER PAINTS A WATER-MEDIA LANDSCAPE

BY BARBARA WHIPPLE

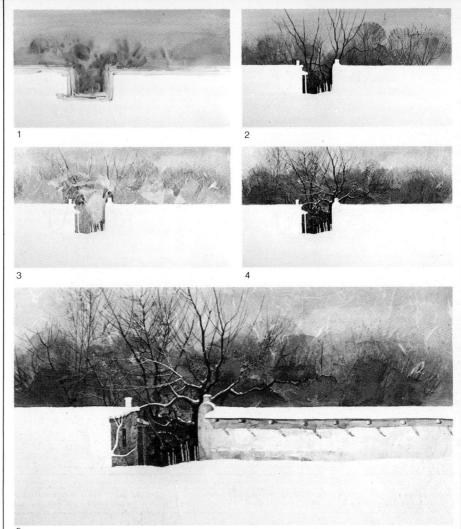

1

2

3

4

5

I T MIGHT BE easy to assume that any artist who lives in a log cabin in a remote mountain area would be morose, temperamental, and withdrawn. Stephen Quiller lives in a log house he built himself in Creede, Colorado, where he is isolated from large urban centers. But instead of being antisocial and temperamental, he is an outgoing and gregarious person—one who is, at the same time, well-organized and dedicated to his work.

A few years ago, Quiller left a full-time teaching position in order to devote himself to his painting. A watercolorist, he began doing experimental paintings using various combinations of the four water-media: watercolor, gouache, casein, and acrylic. When he sought books to help him, he discovered many books were helpful in handling a particular medium, or even two, but that nothing had been written about combining all four water-media in a work as he was doing. So the idea for the book *Water Media*

*Techniques* was born. [Co-authored by Barbara Whipple, the book was published by Watson-Guptill Publications in the spring of 1983.]

Before Quiller begins a painting, he tacks up in front of his easel a collection of his preliminary sketches pertaining to the subject. Some of these sketches may be rather formless—only germs of ideas. Others may be details of subjects done in the most painstaking manner. Still others might be value sketches. But the most important preliminary planning has been going on in his mind: by the time he begins to paint, he will have decided what combination of the four water-media will give him the result he's after.

When he begins a painting, he goes at it with great vigor and impetuosity, for at this preliminary stage, he finds that any accidents which occur can be used to good advantage. Next comes the stage of developing the various planes in the picture. Frequently, he will create a form by first painting the

negative spaces around it, such as a distant field seen through the branches of a tree. Then he moves in for the final details and finishing touches, applied with extraordinary control and deliberation.

### DEMONSTRATION

The initial sketch for *Taos Adobes* was made during a February trip to Taos, New Mexico, where a group of adobe buildings and a clump of cottonwoods caught the artist's eye. First, he made a series of black-and-white sketches and then several color studies on the spot. Back in the studio, he looked them over and made further compositional and value studies. At the same time, he made some decisions about composition and technique. He shifted the focal point of the composition to the left and added shadows under the vigas for greater interest. He decided to do a collage for texture, using frayed cheesecloth to suggest the wispy branches of the trees and rice paper for the irregular surface of the adobe walls.

Quiller finds that acrylic matt medium is an excellent adhesive and dries transparent. Acrylic colors are very intense and can be veiled to advantage by collage materials. Moreover, acrylics are insoluble when dry. Watercolor responds well to rice paper and settles into crevices that emphasize its texture. Gouache flows on easily, is extremely opaque, and can be used over rough textures when scumbling light over dark.

**Step 1.** Using a Crescent illustration board #100 cold-pressed heavyweight, Quiller lightly outlines the adobe buildings with pencil. Using an old brush, he paints the upper part of the buildings with Maskoid. When the Maskoid dries, he saturates the sky area with clear water and, using a 1½″ single-stroke synthetic brush, washes on a transparent mixture of yellow oxide and cadmium orange acrylic. While it is still damp, he washes in a mixture of Acra violet and phthalocyanine blue acrylic at the upper sky area and, where the trees are to be, a darker tone of the same color. Touches of burnt sienna acrylic further suggest branches. This is allowed to dry.

**Step 2.** Quiller then develops the tree branches with Acra violet acrylic, using a ¾″ single-stroke synthetic brush. He covers up the lower part of the painting with some newsprint and applies "directional spatter," using a mixture of burnt sienna and burnt umber acrylic. He does this by hitting the loaded brush across the opposite forefinger. More details are added with a No. 5 round synthetic brush and a mixture of burnt sienna and burnt umber acrylic. When the passage is totally dry, he carefully removes the Maskoid.

**Step 3.** The board is covered with clear water, immediately followed by an equal amount of acrylic matt medium, using a 1½″ single stroke synthetic. This is mixed right on the surface of the board. He lays Unryu rice paper over the whole board, beginning at the bottom, gradually pressing out air bubbles with a brush loaded with medium. When the paper is dry, Quiller tears cheesecloth into small irregular squares and presses them along the top edge of the buildings, using more matt medium. Where he needs a straight edge, he trims it with scissors. This application dries. In illustration no. 3, note the softened effect and the illusion of greater depth that the collage materials give to the first layer of intense acrylic color.

**Step 4.** Quiller rewets the area above and around the buildings and saturates it with a mixture of Acra violet and burnt sienna acrylic, leaving some areas untouched. For the intense dark surrounding buildings and fences, he uses ultramarine blue with this mixture, using the tip of a 1″ single-stroke synthetic brush. When this dries, he shifts to gouache and scumbles warm orange tones over the rough, dark cheesecloth, using a mixture of raw sienna and cadmium red pale with a 1″ "Skyscraper" (Robert Simmons) brush. The trees and branches are painted with a mixture of burnt umber, Prussian blue, and alizarin crimson gouache, using a No. 5 round sable. He paints the snow on the branches with a No. 5 round, using a mixture of cerulean blue and permanent white gouache. To emphasize the texture, he mixes raw sienna, cadmium orange, and some permanent

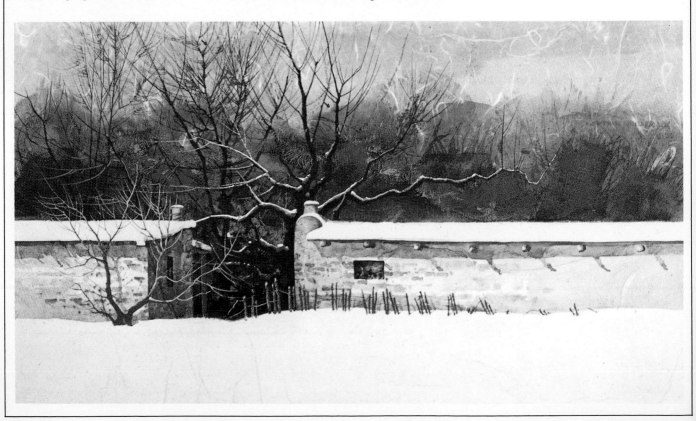

white gouache and drags the paint across a few areas of the background, using a ¼" single-stroke sable.

**Step 5.** Quiller touches the ends of the vigas with Maskoid. Using a ⅝" single-stroke sable, he washes a mixture of raw sienna and cadmium orange watercolor. He applies this to the top of the chimney and the corner of the roof of the building at the right. The same tone is carried over the rest of this building, using a squirrel hair brush. When the paint is dry, he paints in the shadows under the eave and around the chimney and the vigas with a mixture of alizarin crimson and ultramarine blue watercolor.

For the building at the left, Quiller first washes in raw sienna watercolor, using a ⅝" single-stroke sable. When it is still wet, a mixture of burnt sienna and cadmium red light watercolor is dotted on. When this is dry, a violet tone is washed over it. A dark mixture of alizarin crimson and ultramarine blue watercolor is used for the window.

**Step 6.** The same dark mixture is used for the eave line, while the snow on the porch roof is painted with cerulean blue. The Maskoid at the end of the vigas is removed.

To suggest reflections in the window of the building at the right, it is touched with cadmium red light watercolor applied with a ¼" single-stroke sable; then when the paint is dry, a transparent wash of ultramarine blue and alizarin crimson is floated over and around the red shapes and, finally, a deeper tone is washed in. A warm mixture of raw sienna and cadmium orange watercolor is washed on the left wall and painted around the tree form with a ⅝" single-stroke sable. The shadow on the eave and behind the tree is done with a violet watercolor wash.

The tree at left is painted dark where the form is in front of light areas, and light where it is in front of dark areas, using a mixture of raw sienna and burnt sienna watercolor. Quiller does this final passage with extreme deliberation, studying every brushstroke as it's made. He deepens the shadow under the eave of the building at the left close to the branches to make these branches appear lighter. He changes to gouache, using a mixture of permanent white and raw sienna to paint over the rough cheesecloth, where the branches project across the dark window and above the roofline.

He paints the fence with a mixture of raw sienna and burnt sienna watercolor, using a No. 5 round sable, and the wire is painted in an irregular way, using ultramarine blue and burnt sienna watercolor with a No. 3 round sable. The adobe brick texture is made with a mixture of raw sienna and burnt sienna watercolor and a No. 5 round sable. Finally, in the foreground, he applies a light transparent wash of cerulean blue watercolor with a squirrel hair brush. This sinks into the texture of the rice paper, enhancing it and reducing the brilliance of the foreground passage.

The completed work: *Taos Adobe*, 1982, acrylic, watercolor, and gouache, 15½ x 27½. Collection Jim and Ruth Brennend. •

# USING SOFT AND HARD EDGES IN WATERCOLOR

BY TIMOTHY J. CLARK

Above, right: *Passages III*, 1983, watercolor, 22 x 30. Collection Mr. and Mrs. Charles Elliot. This painting is part of a garden series that deals with mankind in harmony with nature. In this formal composition, the eye is led through several doorways and openings.

Opposite page: This enlargement shows how, in order to make the background area recede, the details were suggested. Only a few accents were added for interest and information. Initially, the plaster wall and floor were painted very wet and loose. At various stages of drying of the underpainting, details of the tiles were added to obtain both soft and hard edges.

MANY ARTISTS are frustrated by the surprises that watercolor presents to them. To be able to control the medium, one must first learn what the characteristics of watercolor are. What is it that the paint wants to do? The beginner may answer that the paint runs, drips, bleeds, and dries too light. But the professional artist welcomes these "wet" characteristics and complements them with "dry" techniques.

"Wet" and "dry" handling are two of the most common watercolor techniques. They relate directly to hard and soft edges (also called "lost" and "found" edges), which can be an expressive and informative graphic tool for the artist. By playing these techniques off against each other, I have found watercolor to be a good vehicle for expressing my vision, thoughts, and feelings.

When well-directed by the artist, hard and soft edges can carry a considerable amount of information. Besides the emotional impact, they can help explain form, direct the eye "through" the painting, trap the eye at the center of interest, describe spatial relations, and explain the subject's lighting conditions. Controlling hard and soft edges gives the painter these positive effects.

Direction can be given to a technique when an artist has an idea and a need to express it. If the artist can identify the way he or she sees the world and can bring out from watercolor the effects that express his or her vision and emotion, unique and meaningful paintings can be created. (Of course, drawing and design skills, plus appropriate color, are also necessary.) By "asking" the painting to carry information, an order begins to take place. If nothing is asked for, confusion sets in. Just approaching the painting with hopes that chance wet and dry areas will work out is risky business.

Returning to the subject of soft and hard edges, the practice of starting a watercolor with light values on a wet paper and ending with crisp darks on the then dried paper is a good general rule; but a problem lies in the arbitrary limitations of painting in that order. If the paper dries too fast, the artist becomes a hard-edge painter. This common problem can be prevented with the knowledge that the paper can be rewetted on any *part* of the painting at any *time* during its execution, even days later.

To rewet a painting, I use a fine mist sprayer (a well-cleaned-out pump hair sprayer) and sponges, plus—my favorite tool—a sable brush of the appropriate size. To rewet an area, just make a single stroke with a wet brush. More than one pass on a wet area may lift off or damage previous work. Remember that humidity will have a great effect on how often you have to wet an area and how fast you have to paint.

My painting *Passages III* has a formal composition and several passages for the eye to maneuver through. The variety of hard and soft areas not only supports the composition, but also has a dramatic impact of its own.

On the carved wood passageway,

the section on the right is lighter and has more contrast because of the sky-light above it. By making one side dominant, the artist can avoid the monotony often found in formal compositions. The strong elements in the foreground (the vigorous plants on the right and the glass door on the left) create a feeling of depth against the freely painted plaster wall in the "rear" of the painting.

To achieve the subtle reflections of the tile floor, I had to rewet that area of the painting several times. The initial wash was cadmium red on dry paper. Onto that very fluid base, I applied a slightly darker and more neutral cadmium red with cobalt violet and cerulean blue in order to indicate the reflected darks from the doorway and some individual tiles. This light area was reworked many times during the course of the painting. Subtle reflections were painted on top of the larger washes.

The darks on the left side of the floor are more definite than the reflections on the right and are also of interest in themselves in that they indicate a pattern. At one point in the process of painting, this pattern got too detailed and busy, so I dragged a wet brush into some of the freshly painted hues. The result was that the floor became unified and visual relief was created. This is also an example of how interesting wet, or soft, marks were added late in the painting.

In the painting *Santa Maria della Salute*, the dome of the church has a soft body shadow across it, but the top shadow is darker because it is cast from the smaller dome on the top. Differentiating between these lighting

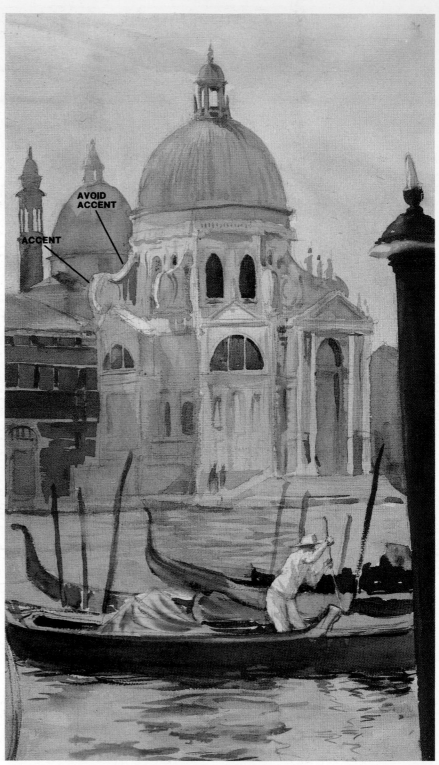

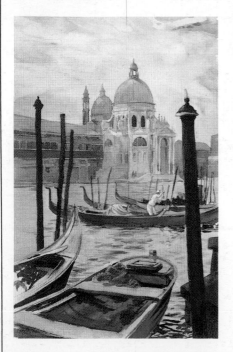

Left: *Santa Maria della Salute*, 1982, watercolor, 41 x 26. Collection the artist. While in Venice on a painting trip, I started this painting on the docks near St. Mark's Square. Although there are dynamic reflections and boats in the foreground, the church looms in the background, bathed in that special Venetian light.

Above: A detail. By taking advantage of drips, runs, and soft edges, along with hard edges and dry brush, a full, expressive technique was developed.

Opposite page: *Portrait of Lisa*, 1982, watercolor, 22 x 15. Collection Mr. and Mrs. Roger Curtis. This portrait required a variety of approaches to capture the different textures of flesh, hair, and blouse. Besides structuring form, the hard and soft edges permit the eye to travel freely from one shape to the next.

conditions not only gives lighting information to the viewer, but also presents a graphic variety of hard and soft edges, develops the form, and helps establish the church as the center of interest.

The main church is quietly echoed by the second dome and bell tower behind it; the latter two were painted simply, allowing them to recede spatially. Although these churches were painted with hard contour edges, they recede because of the limited handling, low contrast, and the fact that their subtle darks act as a frame to the large church in front.

On the left of the main church, just below the dome, is a wall with a compound curve. If the wrong part of this curve had been emphasized, the background would have tended to come forward. To avoid this confusion, accents were placed around the positive end of the form (see detail).

The lower part of the church falls in the shadow of the building on the left and partially in its own shadow. The edges and values are kept quiet to indicate this subdued light and to make the church recede behind the boats in the fore- and middleground. The few marks that pick up a sharp quality are in the windows and doorways, which repeat the shape of the domes.

The water reflects the glowing quality of the church integrated with the reflected sky and the boats. The reflections were painted with a variety of techniques and colors. Part of the water had to be rewetted several times. By studying the painting, it is easy to find within a single wave shape both wet, or soft, edges and dry, or crisp, edges. This effect is achieved by wetting only a portion of the area before putting in color.

In *Portrait of Lisa*, the soft quality of the flesh and the silk blouse are contrasted by the rich darks of the hair. The rhythmic brushstrokes of the hair on the lower left of the painting help the viewer's eye travel up to the head. There, the hair in shadows on both sides of the face forms a "parenthesis," dramatically calling our attention to the facial features.

The ideas outlined in this article are only part of the artist's graphic arsenal. To understand these ideas better, the professional artist might ask if these graphic ideas are now being used in his or her work and how their use, or omission, can help the artist express him- or herself more clearly.

And when things don't go as planned, take it in stride; see how you can incorporate that drip or hard stroke into the existing plan. Once you have ordered your soft and hard areas,

a few surprises can be exciting. With a little direction from you, watercolor will paint itself. As I've said, the real frustration in watercolor usually comes from not placing your order to start with. ●

*Timothy J. Clark lives in Fountain Valley, California. He studied at Art Center College of Design and Otis Art Institute. Clark is a graduate of Chouinard Art Institute and also has a BFA from California Institute of the Arts. He holds a master's in art from California State University at Long Beach.*

*Clark is noted for his landscapes, portraits, and interior studies. His watercolors and oils have been exhibited in the American Watercolor Society Annual, the National Academy of Design Exhibition, the Butler Mid-Year Exhibition, and many others. He has received numerous merit and purchase awards in nationally juried exhibitions. He is listed in Who's Who in American Art. His works can be found in collections across the country.*

*Clark has shared his painting expertise at such institutions as the University of Hawaii and the Coast Community Colleges. His instructional watercolor programs for television have attracted attention because of his ability to make painting seem easy.*

*Each year, many students and artists attend Clark's watercolor workshops in Hawaii and abroad.*

# DOUGLAS ATWILL: PAINTING WITH ACRYLICS

BY MARY CARROLL NELSON

Above: *Mountain Pool*, 1978, acrylic, 44 x 44. Courtesy Adelle M. Fine Art, Dallas, Texas. A summer scene from the upper parts of the Tesuque River in the Sangre de Cristo Mountains. This is the first of a series of paintings, all looking down at water, reflections, and grasses.

Opposite page: *Lamy Rocks with Snow III*, 1979, acrylic, 54 x 38. Courtesy Phillip Casady Collection. Atwill took some 400 photos and selected the seven most interesting ones. This is one of the resulting paintings.

ACRYLIC landscapist Douglas Atwill has found his subjects within 30 miles of his home in Santa Fe, New Mexico, for a decade. As sunrise first brightens the upper slope of the ski basin, at 9,000 feet above sea level, Atwill is apt to be hiking alone through the snowfield with his Nikkormat 35mm camera. "I get excited by first snows or a first sunny day," he says. "They have a fresh look. I search for scenes in the field—it's my version of sketching. Although I do sketch with a Koh-I-Noor Rapidograph pen and India ink, or a Pentel, taking photographs is my preferred way of working."

On one outing, he takes perhaps 30-40 or more shots and has them developed into 3½″ x 5″ prints at a 24-hour place in town. From this quantity, maybe only one photo will suggest a painting, but he checks them all. Atwill handles his prints in a practical and personal manner.

"I compose with the lens," he says, "then I further refine the composition by matting the print." He cuts a window slightly smaller than the print from one side of a folded sheet of bond paper. Then he adjusts the composition of the print in the mat until it

is most pleasing to him and tapes it in. He may tape a mini-matted print near or on his easel. Several are around in his studio. Prints are stored by subject under a number of categories. He goes back through them, frequently looking for new possibilities. Each year he develops 20-30 percent of his paintings from his prints.

Neither exact color nor perfect clarity matters to Atwill in these resource photographs. "Overexposed film makes for interesting washed-out colors. I can remember or supply color. Pattern is what I look for," he explains.

Atwill's themes are not distinctively different from those of many artists who paint in New Mexico; however, his focus distinguishes him from others. He aims his camera directly at a stream or snowfield. The top of the resulting painting may be a dark forested rim of a hill or a limited strip of sky, because, he says, "dark tops of paintings appeal to me."

Sometimes Atwill paints the literal truth from one of his photographs; at other times, only a detail is needed to develop a painting. It is his habit to search his paintings and photoprints, looking for potential paintings hidden within other compositions. He likes to

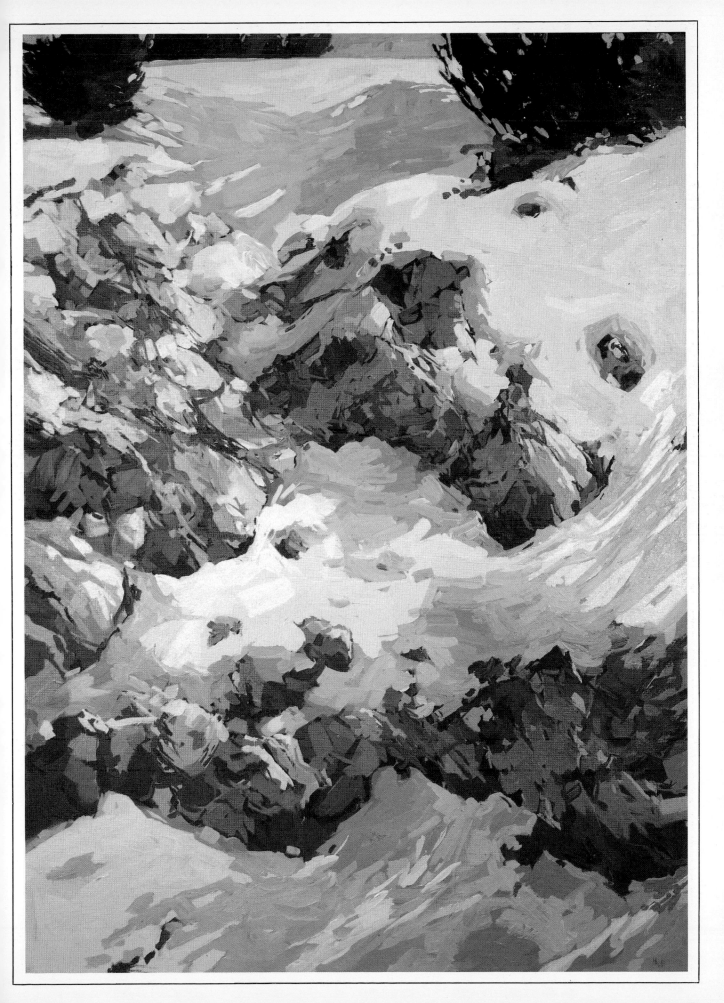

work in series and might concentrate on water falling across rocks in a winter stream for a number of paintings; or a snowy hillside with piñon trees might occupy his mind through variations of size and shape. Woods, rocks, grasses—each theme has its run and, later, he'll return to the subject at a different season. He paints about 100 paintings a year and says, "I throw out another 30."

An assistant stretches his canvases and there are a variety of them ready at any time. He likes pre-primed canvases, but often gives them another coat of gesso. The inert shape of a square canvas has interested him for a long time, but he has begun using rectangular canvases more and more.

Atwill combines his painting with a secondary, and sustaining, career as a real-estate contractor, which he approaches as another dimension of creative designing: "I build a house for myself and if someone buys it, that's okay." Someone always does. He is also an avid gardener and claims that he tends to overdo it. Building, buying, selling, leasing, and gardening claim a part of his day. Painting, though, is his vital necessity. He paints from 7 a.m. to 1 p.m. nearly every day.

In the village of Galisteo, the site of his current passive solar building projects, Atwill has a country studio, but he prefers his town studio right on busy Canyon Road in Santa Fe. "I'm gregarious," he says. He has his easel set up by the north window in one of a long string of adobe rooms he manages. It must have been the dining room in what once was a fine old home, surrounding a portal and a garden where his two German shepherds romp. Art books are stored on shelves in one corner of the studio. There is a mirror hanging behind his easel so he can check his work in progress. Paints and other gear are piled on a big table under the window and part of that gear—his paper palettes—look, at first, like Dada art. Atwill squeezes acrylics onto disposable paper plates; over several days, the plates average over an inch thick and weigh several pounds apiece. Then he throws them out.

A rapid, certain painter such as Atwill finds acrylics perfectly suited to his style. He originally painted in caseins and particularly liked the layered effects possible with them. He devised a system of underpainting and layering acrylics that takes advantage of their quick-drying quality and also developed effective glazing techniques.

His palette consists of titanium white, raw and burnt umber, raw and burnt sienna, yellow ochre, cadmium yellow, Mars yellow, ultramarine blue, cerulean blue, alizarin crimson, and cadmium red medium. He buys large tubes of Liquitex, Shiva, Grumbacher, and Winsor & Newton acrylic paints and uses them together on one canvas with no apparent difficulty.

Using a photograph as a guide, Atwill draws in his big shapes roughly with a ¾″ flat sabeline brush on a fresh canvas, using a mixture of burnt umber and ultramarine blue. He covers the entire canvas with a very thin layer of acrylic. This underpainting will be quite different in color from the final layers. He is not locked into a fixed methodology in his underpainting, but he customarily works in contrasts. For example, if an area is to be dark, he applies a bright underpainting; if it is to be bright, he paints a dull underpainting. For snow, he likes to use a muted violet underpainting.

From this base he adds layers, cov-

ering, changing, and developing them. Before applying the final layer, he adds some gel to his paint to slow down the drying time and give richness to the pigment. He never varnishes. There is a natural variation of gloss in each color; he likes to leave the surface alone when the painting is complete. Atwill arranges for a professional photographer to come to his studio at intervals and take a 4″ x 5″ transparency of every finished painting that is to be sent to a gallery.

*Stream with Snow and Grass*, reproduced here, depicts the first spring thaw in March. In composition, he focused on a frozen stream and a snowy bank against a dark background of trees. As the painting progressed, he tried to get all the areas wet at one time, so he could do some cross-hatching into the wet paint. In the final layers, Atwill used gel with his paint, especially in the mixtures with white. He used almost no gel in his dark mixtures, however, because he wanted to maintain their "luscious transparency."

Atwill points out that in New Mex-

ico streams, the water is transparent, but it does not gleam; the streambed is visible. To make the streambed seem solid in this painting, he added yellow ochre to the area. He says he was so excited by finding this work's motif that he went back into town for more film and took 500 more shots of it: "I've done a whole series on it. I knew when I saw it that it was a gold mine. I could do 60 paintings of it in endless variations. I've said all I want to say in this one."

Atwill moved to Santa Fe in 1969. A fifth-generation Californian, he was born in Pasadena. After army service in Europe, he studied at the Universitá per Stranieri in Perugia, Italy, for a year. Since then, he has returned a number of times to Europe. In 1959, he graduated from the University of Texas in Austin where he stayed on for graduate study in art under Michael Frary. For the next eight years, he was an art director for advertising agencies in Odessa, Texas, and Richmond, Virginia. He began his fine arts career before moving to Santa Fe. Among his paintings are scenes of

Opposite page: *Fir Trunks with Snow*, 1980, acrylic, 38 x 48. Courtesy Munson Gallery, Santa Fe, New Mexico. This work was painted from a sketch done after an early, wet snow in the Sangre de Cristo Mountains.

Below: *Galisteo River at Lamy*, 1981, acrylic, 38 x 54. Courtesy Carson-Sapiro Gallery, Denver, Colorado. "This is a scene I saw every morning in the year I commuted from Santa Fe to a studio in Galisteo. It was painted in the studio from a composite of photos and sketches," says Atwill.

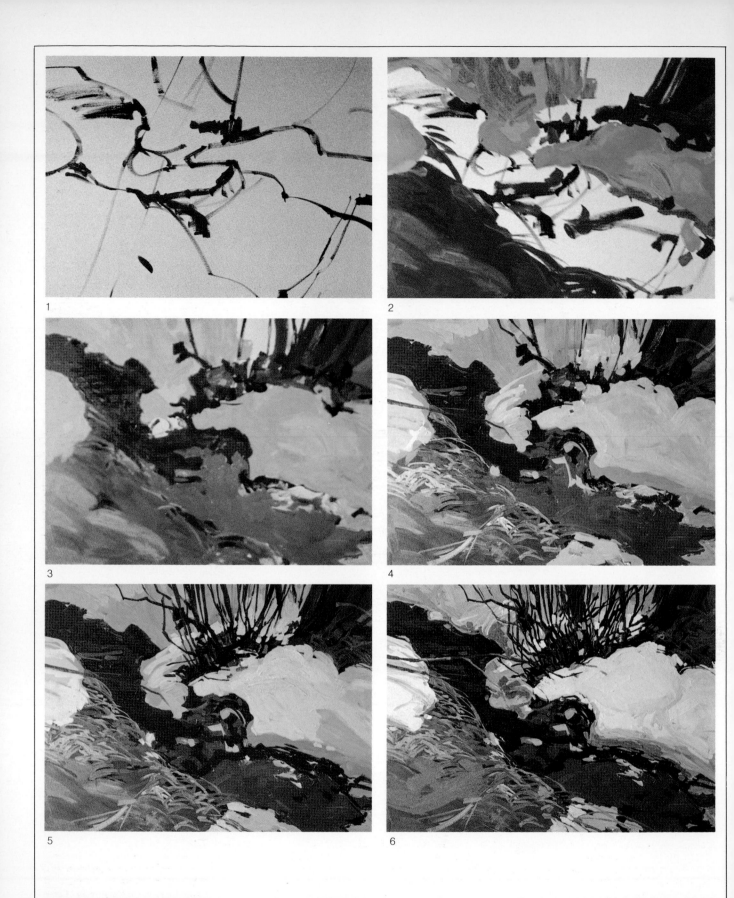

1

2

3

4

5

6

1. Atwill draws his design, using a flat sabeline brush and a mixture of burnt umber and ultramarine blue. 2. The areas where there will be snow and a group of trees are underpainted with a thin lavender mixture of cerulean, alizarin crimson, and white. Some pink patches in the streambed give a late-in-the-day effect. Earth tones—burnt sienna, yellow ochre, and Mars yellow—are added here and there. 3. At this stage, Atwill turns the canvas upside down and treats the painting as shapes rather than as a subject. 4. He strokes in areas of grass and begins to paint tree branches. 5. Atwill continues to enrich the darks and to brighten the whites. At the center right, where sunlight hits the snow, he adds yellow. 6. With a 1'' white nylon acrylic brush, the artist works on the patterns of the branches and those in the streambed. 7. Notice the deep cut in the right snowbank where it appears to be melting and receding with rounded edges. The completed painting: *Stream with Snow and Grass*, 1981, acrylic, 28 x 38. Courtesy Adelle M. Fine Art, Dallas.

7

Greece and Turkey, based on thumbnail sketches done aboard a ship. He painted them from color notes and imagination. Atwill hopes to return to a small island he found in the Mediterranean so he can paint abstractions of the marshes and mountains there, which reminded him in some aspects of New Mexico.

In his early work, his style was more inclusive and "tighter" than it is now. Agnes Sims, an esteemed creative painter in Santa Fe, advised him to do monoprints as a way of loosening his approach, and he has enjoyed doing them. With a brayer and earth colors, he makes almost entirely nonobjective forms. After pulling the print, he paints over it. As a result of this practice and an evolution in his work, Atwill's present style is a generous one in which detail is restricted to only the most broadly suggested grass and shadows with an occasional rock and tree branch pattern. The effect of his painting carries well as a bold landscape.

It is possible that his selection of forms was affected by an Oriental taste that is pervasive on the West Coast. Notably, his viewpoints compare with those of a Chinese landscape painter. "I generally look down on a landscape so that there is no horizon. It is hard to get distance or scale this way. I solve it by looking at patterns and I've learned to judge scale by a piñon tree. However, that is not why I do paintings without horizons; they interest me," he says. In Atwill's work, there is another similarity to Oriental design: the most distant object is often the highest one. "I like edges where a hill meets the sky, a snowbank enters a stream, or a field and forest join together," he comments.

The blond, blue-eyed artist projects a contented healthiness. His life is his work and vice versa. In an understated way, he is enthusiastic about Santa Fe. "It's wonderful to set up your own life," he says. "I find myself being more disciplined and doing more work than when I was in advertising. I hate to miss a day of painting. There are fine artists here, finally able to be professional painters. We talk over our work and occasionally go out sketching together. There's a rich cultural life. I go to the opera and chamber music festival."

Atwill paints constantly and is so assured in his approach that he disclaims an emotional involvement with each and every canvas: "I'm obviously interested in the design of my canvas rather than the emotion. I don't have a preconceived idea of a scene. My feelings don't vary that much from painting to painting. Yet somewhere in every painting, I get interested in the paint itself. The best of my paintings are those where at some point I left the motif and got into the paint. Even if you don't feel like painting, I think you have to work in a disciplined way to make those moments happen." •

*Mary Carroll Nelson is a contributing editor of* American Artist. *She earned her BA from Barnard College and her MA from the University of New Mexico. She is the author of* The Legendary Artists of Taos *and* Masters of Western Art, *both published by Watson-Guptill Publications.*

# PAINTING WITH PASTELS

BY DANIEL E. GREENE

1

2

3

1. *Diane With Kite*, 1975, 50 x 36. Collection the artist. All photos this article courtesy Studio/Nine, Inc., New York.

2. *Susan With A Kite*, 1975, 60 x 40. Collection the artist.

3. *Kite Flying*, 1975, 21 x 29. Collection Dr. and Mrs. Sollitaro.

PASTEL PAINTING is enjoying a rebirth. More works in pastel have been produced and exhibited in the last ten years than in the previous seventy years combined. It should be remembered that the technical excellence of the conservative pastel portraits in the late 18th and early 19th centuries led to the innovations of the Impressionists, notably Degas. After that, serious work in pastel seemed to have ceased, with the exception of isolated studies by a few painters in the 20th century. The medium became the province of less skillful artists, in whose hands it became characterized as delicate, weak, fragile, and generally inconsequential. However, the supposed limitations of pastel and its relegation to a rapid sketch-like category are not based on inherent limitations of the medium. If the necessary steps are taken to equip oneself sufficiently, artworks in pastel can be as completely realized as works in any other medium. Pastel, moreover, has the virtue of being the purest form of painting available. It is pure pigment, held together by a very weak binder of water and tragacanth glue. It has no extenders or fillers. In fact, there are fewer technical complications involved in mastering pastel than are

dealt with in oil painting and water-color.

I've been working in pastel since 1953. In my teaching I try to convey some procedures that are essential to follow in order to solve technical problems. The most important step is to assemble as large an array of individual colors and values as one can. Unlike other mediums, pastel colors are not achieved by mixing pigment with pigment but, rather, are obtained in the premixed stick form and are available, hopefully, in the specific value and color one seeks. Lack of familiarity with a new large set of pastel and little knowledge of organizational methods are the biggest stumbling blocks for artists beginning in pastel. Only a fraction of the colors or pastels available is used in a given painting. But, as I frequently point out, one must have all choices at one's disposal.

Becoming familiar with a set happens as a matter of course. It's not necessary to memorize the names and identifying numbers of all the sticks. It's more useful to arrange the colors by groups with shades and tints together; for example, blues and greens together, oranges and yellows, reds and pinks, browns, grays, and whites. This type of palette-like organization should make finding exact colors easier. It's also a good idea to segregate the colors being used on a given painting in order to keep them ready from session to session.

I recommend becoming familiar with a large inclusive set, such as the seven-tray Grumbacher soft pastel set, or the 270-stick Rembrandt set—and that the set be thought of as the basic source of colors and values. (Unfortunately, even these sets do not provide all colors, and I have found it vital to add additional sets—manufactured in France, primarily—in order to gain some necessary sticks. In addition to the soft pastels, I find a small number of hard pastels come in handy. Hard pastels can be sharpened to a point for drawing and detail.

If this all seems like an expensive undertaking, remember that pastels last a lifetime and only the very frequently used, individual sticks need be replaced, at minimal cost. The initial outlay for materials is a one-time expense.

The surface and support used for pastel painting are very important to the character and durability of the final work. Basically, any slightly rough material that will abrade the pastel and hold it firmly to the surface is workable. Pastel can be employed on a multitude of papers and on homemade granular surfaces. One of the best paper supports is the French Canson pastel paper, which comes in a variety of colors and values. Many handmade papers and watercolor papers are quite interesting and usable. The important considerations in choosing a surface are size, tooth, color, value, rigidity, and permanence. With paper, it is most important that the material be 100% rag.

When selecting a paper, it's important to keep in mind the influence that color and value play in the development of a picture. I favor middle values so that any area not covered with pastel comes through as middle tone. The color of the paper also affects working method. One can choose a color that is either in contrast to or in harmony with the color scheme of the painting. I usually prefer a contrasting base on which to work.

Even though pastels can be somewhat "set" with spray fixative, they must be further protected by being framed under glass. If the support is rigid, it is preferable to use a mat or insert in order to keep the picture away from the glass.

The important considerations in selecting a surface to work on are depth and closeness of the tooth, because they determine how much pastel the surface can hold. The ideal surface is a homemade granular board. Useful granular materials include pumice, marble dust, quartz, and silica. The basic idea is to make a sandpaper-like surface by combining adhesives (such as casein, various pastes, or glue) with granular material, on a sturdy support such as untempered Masonite®. In my book *Pastel*, I cover the mechanics of making these supports. Working the pastel largely becomes a problem of controlling the pressure applied to strokes and getting a feel for the influence of the textured surface. Rough surfaces produce splattered, grainy, irregular textures. Smoother surfaces produce even, sharp strokes. Rough surfaces make possible many more layers of application before the tooth is filled than do smooth surfaces. It is also easier to combine roughness and detail. Smoother surfaces more quickly result in blended and detailed characteristics.

To minimize the possibility of filling up the tooth prematurely, I find it a good practice to use a cushion of five or six additional sheets of paper beneath the top sheet. I secure the papers to a backboard, with six or eight large clips. It is helpful to tilt the top of the board forward in order to allow the pastel dust to fall away from the surface of the picture. Since the pressure applied to each stroke is very important, it is advisable to make the board and easel as steady and immobile as possible.

Generally speaking, one proceeds by using a light touch, resulting in a

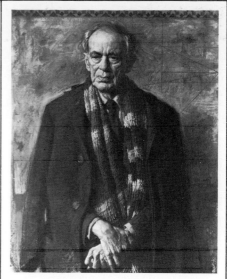

4. *Robert Beverly Hale*, by Daniel E. Greene, 1976, 50 x 36. Courtesy the Art Students League, New York.

grainy stroke, with much of the paper coming through, and then, as the picture becomes more resolved, advancing to heavier strokes, with more thickly applied pastel. I normally combine these controls with a progression from relatively harder pastels to increasingly softer pastels. The softer the pastel, the more quickly it fills the tooth.

If the tooth seems to become "lost," and pastel is repelled by the paper, very soft pastels will often still register successfully. Soft pastels can be applied using the tip or edge of the stick, or they can be deliberately broken, and the flat side used. The sharp edges will produce crisp strokes, and the rounded blunt ends give wider, less linear effects. The hard pastels can make chisel-edged strokes—using their sides—or a variety of effects, using the sharpened tip.

One color can be placed over another to achieve "hybrid" effects. Greater variety is possible by altering the pressure of the application. Usually, I advocate keeping the strokes open and spaced. Through the application of many strokes, a tightening will gradually emerge. Because pastels are matt, problems of glare and reflection are not present. Therefore, it is possible—and often desirable—to employ a variety of directions with one's strokes. In pastel, the "fusing" or blending of tones to achieve an effect of softness is easy; one can use pressure, blending with the fingertips or a paper stump—or take advantage of the irregular splattering that occurs on rough surfaces. In order to avoid pushing the pastel into the tooth and filling it up, which causes an appearance of strokeless, smooth painting, I do no blending. My own personal tastes lean toward producing clearly visible strokes.

5. *Still Life With Crepe and Kite*, by Daniel E. Greene, 1976, 48 x 72. Collection the artist.

Pastel fixative in spray cans can be beneficially used at any time while a painting is in progress. The fixing quality will be minimal, but the addition of fixative will impart slightly more tooth to the surface. However, fixative, if applied more heavily, will darken the light colors and, at a certain point, lighten the very dark colors. These changes to the pastel can be likened to the tone changes in oil paintings achieved by glazing, and they can be deliberately used to affect changes in value and texture. A final fixing is best done very sparingly to avoid changing the finished picture. Fixing does not render the picture permanently protected; it must still be covered with glass to avoid the possibility of its being smeared. No fixative has yet been invented that will permanently protect an unglazed pastel.

These are some of the technical considerations one should keep in mind when using pastels. They may or may not seem difficult, depending on one's liking for the medium. A solid foundation in the skills of painting are, in my judgment, even more important to know than the specifics of pastel technique. However, the spontaneous quality, the elimination of drying time, and the relative ease of technique make pastel an ideal material with which to express oneself. •

**Daniel E. Greene** *studied at the Art Students League of New York on scholarships. In 1963 and 1964 he was the recipient of two foundation grants; since then he has won many awards and prizes. In 1967 he was elected to the National Academy of Design and began teaching there and serving on the council. Represented in more than 100 collections, his works are in The Metropolitan Museum of Art, the Smithsonian Institution, and the U.S. Senate, to name a few places. A nationally known portrait artist, Greene is a member of the National Academy of Design and the Pastel Society of America (he is Honorary Vice President). His book Pastel was published by Watson-Guptill Publications in 1974. He currently teaches at the Art Students League and conducts workshops in Gloucester, Massachusetts, and around the country.*

# WORKING WITH OIL PASTELS

BY JOHN T. ELLIOT

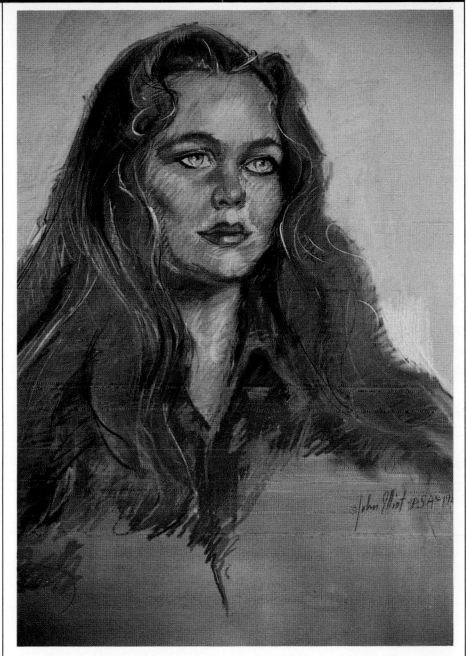

Right: *The Artist's Daughter, Hope*, 1982, pastel, 24 x 18. Collection the artist. Sometimes I paint a portrait totally on impulse. In this case, Hope walked into my studio. She had a special look in her eye; all I wanted to do was to capture that particular expression.

Opposite page: *October on the Hudson*, 1982, pastel, 12 x 16. Collection the artist. While walking along the Hudson River near my studio, I noticed the evening light playing on the autumn foliage. I captured that moment with a limited palette of blue-grays, brown-grays, cadmium orange, ochre, red ochre, and cerulean blue.

I am a pastelist because I love the freedom and the immediacy of working with such a colorful medium. I can capture fleeting effects surely and spontaneously while the painting develops quickly. I have, however, been troubled by the drawbacks associated with traditional soft pastels, particularly the dusting or chalking of the pigments. Not only does this affect the final painting, resulting in fragile works, but the dust permeates the air around the painting-in-progress.

My solution to these problems was to switch to oil pastel, a medium that has been available for a number of years. I have become so convinced of the value of the oil pastel medium for artists that I founded the Oil Pastel Association to promote oil pastel paintings among galleries, museums, and the general public, as well as artists who are just beginning to explore this new "old" medium.

### WHAT IS OIL PASTEL?

Just what is this new "old" medium I am speaking about? Oil pastel is pure pastel pigments combined, not with gum tragacanth as in soft pastel, but with a very slight amount of pure grade linseed oil to bind the pigment into a workable stick.

In earlier years, all one could find on the market was a low-grade oil pas-

tel of relatively few hues, fugitive dye content, and questionable purity of materials. Often, the sets were sold as variations of children's crayons. However, recently, Holbein has distributed a professional line of oil pastel—225 colors of permanent nontoxic pigments. Other manufacturers are either reviving their own professional grades of oil pastel or developing new brands, particularly with manufacturers in Japan, to utilize the lustrous Japanese pigments into new professional lines of oil pastel.

There are various degrees of softness and workability in the available professional oil pastels. A sample tryout of the various brands will prove instructive and very pleasant to the artist. (As a special note, in traditional soft pastel, one can get a pastel pencil to use for fine detail. As yet, there is no such thing as an oil pastel pencil; a grease pencil is not a comparable substitute.)

### LIMITED PALETTE

Although I work extensively with the whole line of Holbein's colors, augmented by Pentel, Niji, and, occasionally, other brands, I find that when I am planning an "on location" trip and can take only a limited number of colors with me, I pack the following Holbein colors:

| | |
|---|---|
| 5B | chrome yellow |
| 5C | cadmium yellow |
| 10A | cadmium orange |
| 13A | scarlet |
| 13C | Permanent red |
| 13F | crimson |
| 26A | oxide yellow |
| 26B | raw umber |
| 26D | English red |
| 26E | Van Dyke brown |
| 26F | burnt sienna |
| 26G | Venetian red |
| 26H | red ochre |
| 32A | black/white (noncolor #1) |
| 32B | cold gray (noncolor #2) |
| 32C | warm gray |
| 38B | cobalt blue |
| 45D | deep green |
| 45F | oxide of olive |

### SELECTION OF GROUNDS

I select grounds for oil pastel paintings along two major guidelines. First, the ground must have enough "tooth," or roughness, to accept the pastel. Pastel or charcoal paper, sandpaper, unprimed or primed canvas, or handmade rag paper are all acceptable. I prefer to choose pre-tinted grounds in medium tones.

Second, the ground must have enough strength to hold up under strong pastel application and plenty of "working into" the surface. I find Canson Mi-Teintes papers premounted on boards (which I import from France; it may soon be distributed nationally) especially suitable for large compositions and portraits.

### OTHER EQUIPMENT

Oil pastel as a medium does not require extensive equipment. For location painting, I begin preparations with a drawing board. On this, I tape a selection of pastel papers, one on top of the other, with masking tape. These are the papers upon which I do my pastel paintings. Over this, I tape a cardboard backing which protects the pastel paper both before and after it has been painted upon. I attach extra pieces of tape onto the back of my drawing board so that I won't have to carry the actual roll with me. If I am traveling a long distance, I put this package into a large presentation case portfolio; otherwise, I just tie a "department store" package carrying handle to the assemblage. When traveling by car, I bring my French easel, a portable easel that unfolds and contains a built-in materials box. I find it useful to buy thin pieces of foam at the local craft shop to fit into the boxes of colors in order to keep the

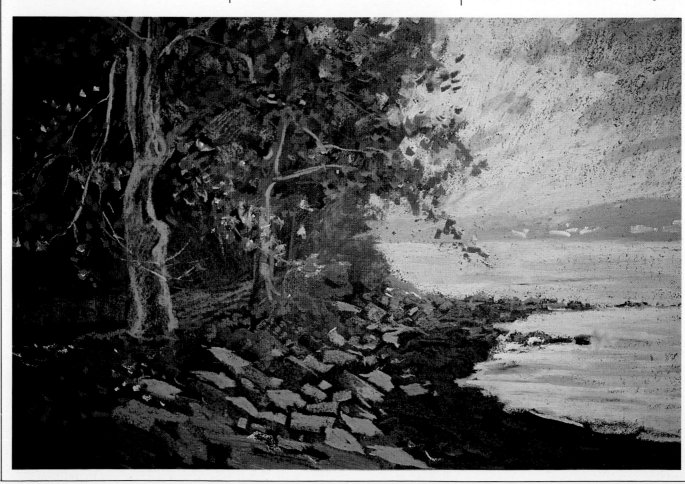

sticks from shifting and smearing while en route. Since oil pastels have a tendency to leave a residue on the fingers, I keep a few paper towels handy for cleanup after painting.

These same items, in permanent form, are used for studio paintings. In my studio, I have several large studio easels, assisted by a movable permanent taboret which holds my oil pastels. If you don't have an artist's taboret, efficient substitutes are small desks or end tables, equipped with tackle boxes, toolboxes, or other compartmentalized boxes where you can keep your oil pastels separate and organized.

Of course, when on location, one paints under natural light. In the studio, even north light doesn't always suffice. As an adjunct to my career, I have produced numerous motion pictures and videotapes on art and artists. Hence, I have acquired numerous studio lights—everything from giant Hollywood superfloods to tiny minispots. I find that, for studio painting—certainly for portrait and figure work—the best all-around lighting system is a set of two quartz lights with barn doors and focusing options.

Other items that may be useful for special effects are single-edged razor blades, white or clear art wax, a small bottle of turpentine or rubber cement thinner for wash effects, and a stiff brush or two.

## LAYING IN THE PAINTING

I do most of my painting from life. If I've observed an interesting location or seen an interesting face or stance, there—on the spot, if possible—I try to catch the vision that moved me. Observe, analyze, feel . . . I instinctively reach out for my pastels and drawing board and make those first clear strokes of my visual statement. I continue blocking in, playing boldly with colors. That moment, that excitement, must not be lost.

To support this spontaneous creative process, the artist must have acquired a thoroughly internalized mastery of technique and materials. Composition, tonal balance, color theory, anatomy, line, and form—all must be second nature. The workability of the pigments, the limitations presented by the surface chosen, and the results of intermixing and blending are all learned through the experience of actually working with the materials.

I find that, as with an athlete or master dancer, thorough initial training is not enough. I must constantly be warming up, reviewing the theory, refining my technique. For this reason, I am known as the artist with the sketchbook. I constantly sketch. Even at parties, I've been known to slip book and pen out of my pocket and quickly sketch a face or a group in conversation. It matters little if great drawings result; what is important is maintaining the fluidity of my hand.

## DRAWING TECHNIQUES

Once I actually take the oil pastel in hand, I think about the kind of strokes I want. I don't favor, as a rule, paintings built up of many small delicate lines. I prefer to match the vibrant colorings attainable in oil pastel with strong vibrant strokes.

I rely heavily on stroke blending to build up color. This blending occurs when strokes are overlapped on other strokes. Here, the oil pastel itself is used as the blending tool. Elsewhere, I use my finger, a soft cloth, or a bit of wax. I find that if I intend to do a major area of blending, I instinctively hold and slightly knead the oil pastel stick in my fingers, to warm it slightly. This slight elevation of heat allows for easier blending of the colors. Working under sunlight or warm studio light elevates the temperature of the ground and also causes easier blending.

True glazing cannot be done with oil pastel. However, I make extensive use of modified glazing to unify an oil

Left: *Winding Lane*, 1982, pastel, 12 x 16. Collection the artist. This work is an affirmation of why I always carry a set of oil pastels and papers in the glove compartment of my car. While driving on a rainy afternoon, I spotted this very moody scene. I just had to park and bring it home with me.

Below: *Motif #1*, 1977, pastel, 9 x 12. Collection the artist. On a painting trip to Cape Ann, Massachusetts, I felt I could not pass up a quick interpretation of this legendary scene. I chose to exclude most of the details and concentrate on the essentials of this boatscape. To my knowledge, this is the last painting made of this scene, as the fishing shanty burned down shortly thereafter.

pastel painting. I will purposely cover a large area, or even the complete painting, with a thin sketchy layer of a basic color of the work. I then blend this layer into the details of the painting. The unifying layer disappears and a newly harmonious painting emerges. I especially rely on this technique in portrait and figure paintings.

When I teach oil pastel workshops, I find that beginning oil pastelists often apply the medium too lightly; this results in a weak "coloring book" effect. Except for deliberately delicate compositions, apply the oil pastel heavily, forcefully; work it into the paper, build up the layers. The final result is as massive and important a painting as one worked in any of the traditional media.

## SPECIAL OIL PASTEL TECHNIQUES

Oil pastel has certain inherent capabilities which you, as an artist, might want to explore. One of the possibilities is creating wash effects. Oil pastel, after all, is based on an oil medium. Therefore, if one takes a brush and a bit of oil solvent, such as rubber cement thinner or turpentine, one can create wash effects, either by applying light layers of oil pastel onto the ground and then washing over the area with a stiff brush dipped in solvent; or by taking a stick of oil pastel and with a solvent-dipped brush, lapping the oil pastel onto the brush before applying to the ground.

Another technique to explore is a scratchboard technique. After working thick layers of oil pastel into the ground, I paint over the whole with an opaque medium. I then use scratchboard pens to etch out a design.

Another special oil pastel technique is the reverse print process. I make my original design with a thick application of oil pastel on a strong ground. Paper fabric, such as Hypro, works well. Then I take the print stock, so to speak, lay it facedown on another ground, and through the application of heat and pressure—an ordinary iron is ideal—I am able to create up to three rather unusual reversal prints.

## TRANSPORTING, STORING, AND FRAMING

What about the care of the final oil pastel painting? That is a delight! Although it is preferable to transport matted oil pastel paintings, they can be transported safely one on top of the other, as long as no grinding or crushing pressure is applied to them.

Storage of unframed oil pastels should be in acid-free mats or in acid-free museum boxes or folios.

As far as framing and displaying oil pastels, the requirements are equally as straightforward. Oil pastel should be framed under glass, with a thick mat creating a separation between the oil pastel surface and the glass. Plastic should not be used except for possible short-term transportation for exhibition, because static buildup on the plastic eventually causes migration of the looser parts of the painting to the plastic viewing surface. One definite word of caution: Never, *never* use fixative! First, it is not even necessary; second, it can selectively modify colors.

Oil pastel paintings can be displayed and enjoyed under most normal home and museum conditions. The cautions are few: Oil pastel paintings should not be displayed under conditions of intense heat, since this causes softening and vulnerability of the surface. Nor should oil pastel paintings—nor any paintings, for that matter—be exposed to prolonged conditions of dampness or continuous strong sunlight or fluorescent light. Apart from that, common sense should dictate reasonable display conditions.

Information for galleries and buyers is very simple. Provided one has worked with professional quality grounds and has taken the care to invest in professional permanent pigment oil pastels, the artist can deliver the most permanent and durable works of art possible. As in soft pastels, the pigments are permanent, but the extreme fragility due to trauma is nonexistent. Since oil pastels contain such a small percentage of oil and since they need no varnishing, gradual yellowing or inherent darkening over time is not a factor. Nor does the strange process of soot amalgamation into synthetic media, such as some acrylics, take place.

The oil pastel medium for the professional artist is portable, versatile, and nontoxic and can produce the most vibrant, beautiful paintings, portraits, and compositions one could hope for! ●

*John T. Elliot is an award-winning artist who has exhibited widely in museums and juried exhibitions both here and abroad. Elliot is president of Graphics for Industry, Inc., a firm specializing in visual communications. A popular teacher and lecturer, he is currently producing a series of art instructions and documentaries on prominent American artists on videotape.*

*Elliot is a vice-president and board member of the Pastel Society of America, juror of the Salmagundi Club, and a member of the Society of Illustrators. He is currently completing a book on oil pastels.*

*He is listed in* Who's Who in American Art, Who's Who in the World, Who's Who in Finance and Industry, *and numerous other such publications.*

*Elliot lives and works from his historic home and studio in Upper-Nyack-on-Hudson, New York.*

*In the Artist's Studio*, 1980, pastel, 24 x 18. Collection Chung-yen Mao. These flowers were sitting on the table near the window in my studio. I was intrigued by the different textures and the upside-down reflection of my neighborhood in the vase.

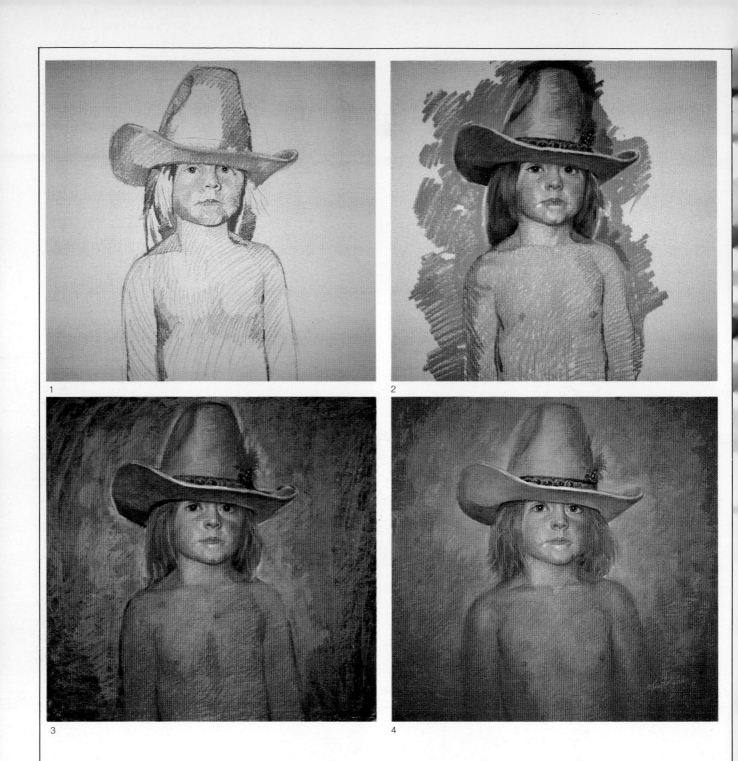

1

2

3

4

**Step 1.** In this planning stage, I concentrated on two things. First, I made an accurate drawing of my subject—my son, Gilbert. Second, I planned the palette. Note that the drawing is not done in a "stock" umber, but uses the color scheme of the final painting. Underpainting for the hair was done with Holbein's 45F oxide of olive, combined with 26C raw sienna.

**Step 2.** In this stage, I established the complete palette for the painting. I chose 26L Indian red for the background underpainting, with 26F burnt sienna, 26C raw sienna, 26B raw umber, and 26H red ochre for the hair area. I used 38F cerulean blue for the bluish facial tints. I concentrated on using valid tonal relationships.

**Step 3.** By this point, I was working over the whole painting, revising the drawing and reinforcing the structure. I used an oil pastel technique for the background (laying on a thick application of color, then scraping away, as in oil painting, first with a flexible palette knife, and then with a single-edged razor blade).

**Step 4.** Now I needed to unify the painting. I did this by using the oil pastel technique of modified glazing, as described in the article. Then I reinforced the focus of the painting—the eyes and expression of the mouth—by subduing the background texture and details and by concentrating the light on the face. The completed work: *The Artist's Son, Gilbert*, 1982, pastel, 26 x 26. Collection the artist.